How to Sell Art Online: The Complete Guide
By
Gary Bolyer

Table of Contents

Smart Art Marketing FREE Video Training

Free eBook Reveals Secrets to Selling Art

Why Some People Almost Always Make Money Selling Their Art

Choose Your Online Platform and Build Your Foundation

Overview

Chapter 1 - How to Become a Pro Art Blogger

Chapter 2. Setting Up Your WordPress Blog the Right Way

Chapter 3. Your Goal: Become an Authority Website

Chapter 4. How to Create a Professional and Profitable Newsletter

Chapter 5. The Basics of Online Marketing

Chapter 6. E-Commerce Flowchart and Business Plan

Copyright © 2019 by Gary Bolyer. All rights reserved

No part of this publication may be reproduced or transmitted in any form or by any means, electronic or mechanical, including photocopy, recording or any information storage and retrieval system now known or to be invented, without permission in writing from the author Gary Bolyer, except by a reviewer who wishes to quote brief passages about a review written for inclusion in a magazine, newspaper or broadcast.

Smart Art Marketing FREE Video Training

If you'd like to find out more about how to nurture your audience, make more sales, and automate your marketing – go check out this FREE 3-part video series masterclass training at GaryBolyer.com.

I'll take you through everything in this book via video – and a ton more to boot.

This free video training series has helped over 10,000 artists and entrepreneurs grow their online art business. And for those of you ready to take it to the next level, there's a premium option too – and enrollment is officially open.

Free Marketing Training for Artists

Video 1
5 Steps to Selling Art Online

5 Steps to Selling Art Online

Forget overwhelm: Use this five-step formula to focus on the marketing that brings results: how to grow your audience, find more readers, and sell more art

Video 2
5 Rookie Mistakes

5 Rookie Mistakes Artists Make Online

The top 5 rookie mistakes most artists make selling art online and how to avoid them like the plauge

Video 3
7 Top Tools

7 Tools I Use to Grow My Business Online

Steal this exact setup that I use to grow my art business online. And best of all, everyone of these tools are FREE

Go check it out here (it's free): GaryBolyer.com

I'll see you on the inside! Gary Bolyer

Free eBook Reveals Secrets to Selling Art

So, you want to sell your art? Here are surefire strategies no one is telling you about.

Why do some artists **make money so easily** — while you try everything possible and get barely enough customers, sales and profits?

What if there was a way you could **convert 15%, 25%— even 50%** or more of your customers, galleries, how much more money would you earn as a result?

If you could read just **one** eBook about how to turn your efforts into an unstoppable selling machine *Secrets to Selling Art* is it. I dare you to **read** this entire publication and not change the way you sell to art galleries.

Grab my bestselling eBook *Secrets to Selling Art* (it's free): GaryBolyer.com/Free-eBook

Introduction

Why Some People Almost Always Make Money Selling Their Art

Have you ever known an artist whose work was incredible, but they never seem to sell anything? Or what about the opposite? Have you ever seen an artist whose work was not that good, but they sold things all the time and for soaring prices?

You've probably wondered how this could be.

Some artists, without ever really being conscious of what they're doing, stumble upon the right combination of marketing and selling strategies. Their work may not be that great, but something else very powerful is coming into play.

And other artists work hard at their craft and yet never stumble upon the right selling formulas or techniques. And, sadly, their careers flounder. As a result, their beautiful work ends up collecting dust in an attic. Their genius is lost forever. I've known artists like this and probably you have too.

So, what is the dividing line between an artist whose career takes off and an artist whose career flounders? It's simple. It's the word "sell."

You Must Learn How to Sell

For many artists, the word "sell" is a vulgar word. I once thought the same way. I strongly believed that selling was beneath me. I thought my work would just naturally attract the right people at the right time.

I was once too proud and too arrogant to lower myself to sell. I thought selling was something that only the Gallery director or Gallery owner did, and I thought they would do it all for me.

And then I had an eye-opening experience......

My Story of Learning about Marketing and Selling Art

When I first moved to New York City in 1998, I had a chance encounter with a powerful gallery director from Manhattan. I met her at a gallery opening and we became good friends. We would often meet for lunch near the SoHo gallery where she worked.

During her incredible career, she had worked side-by-side with famous American pop art icon Roy Lichtenstein. She took me under her wing, and over the course of several months, taught me everything she knew about how to make it in the highly competitive New York City art world. She introduced me to people. But more importantly, she educated me.

And here is the most astounding thing she told me about Roy Lichtenstein. She said that he spent 80% of his work week marketing and selling. And he only spent 20% of his week making his paintings.

Think about that for just a minute. That means he only spent about one day a week making his paintings. And the other four days of the work week he spent selling and marketing. **She told me that Roy Lichtenstein became an art star because he worked very hard at selling and marketing and not because he worked hard at his painting.**

She told me that if I wanted to be a successful and highly acclaimed artist, I needed to do the same.

There are many artists who have created great bodies of work. The problem is, the sale goes not to the best artist, but to those who can sell the best. And as Robert Kiyosaki writes, "Not being able to sell is very expensive. It costs you untold dollars in lost business!" It can cost you your entire artistic career.

Here's to Your Selling Success....

There's no way around it. You must learn how to sell. You must learn how to sell in person. And you must learn how to sell on the internet, through your website or blog.

This eBook is mainly going to cover selling your art online through a blog, email newsletter and social media.

It's going to give you very specific steps for problem solving, planning, and getting your hands on vital materials, skills, information, and contacts. And it's going to give you a lot of commonsense strategies that have worked for me and countless others.

Remember how I talked about in the first couple of paragraphs of this introduction how some people just stumble along and by accident learn to sell well. Don't rely on accidents when it comes to growing your art career.

Find experts who can mentor you in the art of selling in person and online. But choose your experts carefully.

As you follow along with me through the chapters in this eBook, I will be teaching you everything that my powerful Manhattan gallery director friend taught me and everything I 've learn about selling art successfully for the past 15 years.

Please read these chapters carefully. But more importantly, act. Learn to sell and your art career will always flourish.

Choose Your Online Platform and Build Your Foundation

Your very first step in building your business is to choose your online platform, where your online store and business is going to be hosted and live on the internet.

You are going to want an online store that, at the least, has an art gallery feature to showcase your art as well as other basic pages. It will also need to have eCommerce capabilities so that buyers can purchase your art through a secure checkout page.

Don't worry. Most website platforms today make all of this technical stuff very easy and user friendly. Trust me, if you can navigate through this online course, you have enough tech savvy to deal with building your online store with most platforms.

Where you decide to put your online art business, though, is a very important decision and can affect your success for years to come.

So, make this choice wisely.

You may have time restraints, such as a full-time job and family responsibilities that is going to come into play as you make your decision about building your online art business.

Because of other more important issues in your life, you may have to limit the amount of time that you can dedicate to creating your online business.

This is understandable issue and one that many other artists face. So, you are not alone at this crossroads in your venture.

This section designed to educate you about all your possible choices for online platforms and give you my opinion about where it is best for you to start your business.

Let's look at all of the possible choices you have on the internet today.

They are:

1. Art blog
2. Personal website (I also call this a static website like you would build with Squarespace)
3. Group art sites (These are sites like Etsy, Fine Art America, Absolute Arts, and many, many others too numerous to mention here)
4. Auction sites (The most well-known site is eBay, but there are others)
5. Social media platforms like Facebook pages, Instagram, or Pinterest, etc.

Like I mentioned above, time restraints and other responsibilities may come into play as you ponder these choices.

Or, you may already have an Etsy shop or eBay store up and running. If that is the case, you may want to consider starting an art blog to further the reach and scope of your brand online.

Again, these are all extremely important choices, and need to be made carefully.

The next section will help to further clarify these choices and get my opinion on which direction I think is best for your online art business.

Art Blog, Group Art Site, or Personal Art Website? Which is Best?

Have you been thinking about joining the growing ranks of artists online?

But are you confused about which direction you should take on the internet?

There are lots of directions you can take when it comes to promoting your art on the internet. Some artists go with a group art site like Etsy, eBay, or Art in America Mall.

Other artists create a personal website with just a gallery. And some artists start an art blog that contains valuable content that attracts and keeps readers.

But which of these directions is the best when it comes to selling your art online?

Have you ever given it much thought?

Which of these choices will lead you to a truly successful and abundant artistic life on the internet?

These are excellent questions to think about when you are trying to promote your art online.

But sadly, most artists never give these questions much thought. They just forge ahead without much of a marketing strategy at all.

And sadly, most artists will fail online. It's sad but true, 97% of all online art businesses will fail in their first year.

Let's look at each of these choices and see which is best, which will give you your best chance to succeed online in the long term.

Group Art Sites and Auction Sites

There are many, many group art sites and online auction sites. In fact, there are too many for me to list here.

But you probably know most of the major ones, sites like Etsy, eBay, Art in America Mall, Absolute Arts and Fine Art America.

Many artists flock to these group sites hoping to strike it rich on the internet. They think that the huge traffic that comes to these sites every day will translate into name recognition and sales for them.

But sadly, this is rarely the case. In fact, group art sites are NOT the best place to grow your online business.

Why I don't Like Group Art Sites

There are 2 reasons I don't like or recommend group art sites.

The first and foremost reason is that you are digital sharecropping.

What is digital sharecropping?

It simply means that you are building your online art business on somebody else's land. This is never a good long-term strategy.

Think about it for a minute. When you build your hard-earned art business on somebody's else's land in Cyberspace, you are setting yourself up for all kinds of problems in the long haul.

These sites can and often do change the rules. Facebook is constantly changing its rules and algorithms. Lots of times these frequent rule changes play havoc with your business.

You are not master of your own universe because somebody else is making the business rules. Your business is at the mercy of someone you don't even know.

Also, these sites can go out of business or become extinct overnight. Remember Myspace?

If they become extinct or less popular, you will too.

Never tie yourself to the fate of another business.

The second reason is that it makes you look like a commodity. The last thing you want to be when you are an artist is a commodity.

Commodities often sell for the lowest prices.

This is the sad truth about group sites: everybody looks the same and so the sell goes to the lowest price.

Pricing on these group art sites always spirals downward as artists try to compete for the next sale. Anybody can lower their prices and go out of business. Live by the low price, die by the low price.

Personal Art Website

Personal art websites are better than group art sites, but they are not the best choice.

Why?

Personal websites, also known as static websites, are just that, they are static. They usually just have a few pages that do not change very much or very often.

This is the kind of site that you would build on Squarespace. This is also the kind of site that I see a lot of artists put up online.

They usually have a home page with the artist's name and profile picture. Then they have a bio page that has a few glowing paragraphs that they have written about themselves. And then finally, they have their art gallery pages with lots of their paintings with descriptions and prices.

And that is it, the total effort they make for their online art business.

It is usually two or three very boring pages that are very static (meaning that it doesn't change very much or very often) and is usually not very well designed or very interesting to look at.

Because your site is static, first-time visitors don't have much of a reason to return or keep coming back.

They see it all on the first visit and then click away never to return. And they forget about you very, very quickly.

It's very difficult to make a static website interesting enough to keep visitors coming back.

Search engines, especially Google, are not that crazy about static websites and so they often don't get indexed well. This means fewer visitors from organic traffic to your site over time.

Art Blog

An art blog is the BEST way to promote your art and art brand online.

Why?

An art blog lets you be master of your own universe. When you have an art blog with your own dot com address, no one can tell you what to do or what not to do. Am I right?

You make all your own rules.

This is the best long-term strategy for growing your art business.

Also, an art blog allows you to create fresh, quality content on a regular basis.

Fresh, quality content means readers will keep coming back for more.

And search engines love fresh, original, quality content.

An art blog that provides this will automatically keep moving up in the search engine index ratings. This means more daily traffic to your art blog, not only from organic search traffic, but from returning readers who want to learn more from you.

Hands down, the best direction you can take to grow your online art business is an art blog.

For my money, nothing better will give you that leading edge and put you in that 3% of artists who will finally share the big money pie online.

Now, an art blog is a lot of work, and requires a lot of time and effort to make it successful. And that is why a lot of artists often go with the other choices online.

But never underestimate the power of an art blog to bring you true success online. When done correctly, art blogging is by far the best choice for growing your brand online.

When building your art brand online, think in the long term, play the long game.

Which choice will give you the most options for growing and expanding your brand online?

When viewed from the long term, I think that you will have to agree with me that an art blog by far gives you the most options for growth and expansion of your brand online.

Make Your Choice and Act

At this point you should be clear about all the choices you have about where to put your art business online.

You should weigh the choices along with your personal situation, job and family responsibilities. Based on this information, you need to take the proper action now on the best choice for your situation.

If you decide to open an Etsy shop, eBay store, Fine Art America gallery or other group site, you just need to create your art gallery on the platform that you choose.

This is very easy to do and can only take minutes to have a live site going with your chosen images.

Each site is different, and so I won't go into the details of those here. But again, it is very easy, and you should have no problems.

If you already have a website, Etsy shop, eBay store, Fine Art America or other group site, then you need to begin focusing on building your marketing funnel to enhance your sales. Chapters 2, 3 and 4 go in-depth on this information.

You could also consider starting an art blog which would help you broaden your marketing reach and help establish you as an authority in your area of expertise. Becoming an authority by blogging is an excellent way to increase your customer base and grow your following and profits.

Chapter 1 will focus on starting and running an art blog. If you have decided to go with an art blog for your online store, then follow the steps in this chapter carefully. They will show you how to become a Pro art blogger.

Overview

Before you begin the reading the chapters, I want to show you the **big picture**–where this plan will take you in building your online art marketing strategy.

As you work through the eBook, you will be learning how to build and put in place each of the important parts of the strategy shown in the diagram. This article will give you a summary of each of these topics. You will also be given an exercise to do that will compliment and fulfill the direction of the plan.

As you build each step in this plan, you will be creating multiple streams of income. You will create income from sales of art information products, webinars, and products from your art gallery, which will include originals and reproductions.

Your personal website, group site or art blog is the main foundation in this plan.

Your website is the core, the hub from which all other parts of the plan emerge. This is where your art and other products will be showcased and offered for sale on the internet.

It is also where you will provide your original content if you decide to go with an art blog as your website. Offering high quality original content plus quality products is the true path for success online.

If you decide to start an art blog, I recommend a WordPress blog. WordPress is, without question, the best blogging platform available. WordPress is easy to use. It can be set up in

only minutes. And it can grow as your business grows. And best of all, it's free to set up.

I also recommend that your site be self-hosted. That means that you should have your own dot com address, and your own hosting service. This can come later if you like

a year. You can do the same if you like. It's completely free to do it this way. And it gives you a chance to get into blogging and test the waters a bit before you go "pro" with your blog.

The diagram below shows the 6 Key Elements needed for a successful online business.

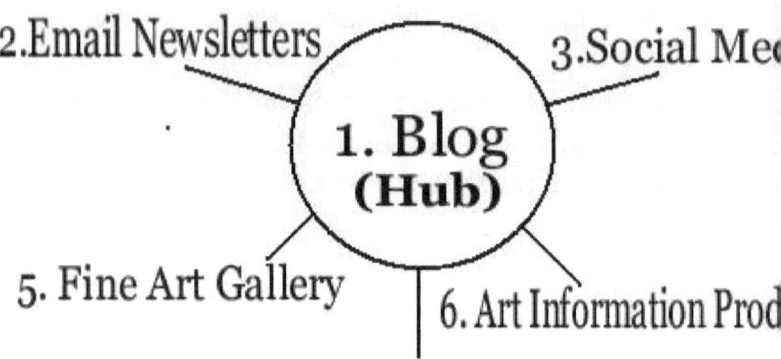

1) Hub Foundation

The website is the main ingredient in this plan. Your website is the core, the foundation and hub from which all other parts of the plan emerge. Choose this carefully. If you decide to start an art blog, Chapters 1 and 2 will show you how to create and run your art blog like a pro.

I recommend a WordPress blog. WordPress is, without question, the best blogging platform available. WordPress is easy to use. It can be set up in only minutes. And it can grow as your business grows. And best of all, it's free to set up.

I also recommend that your site be self hosted. That means that you should have your own dot com address, and your own hosting service. This can come later if you like.

I started my WordPress blog without being self hosted and ran it that way for about a year. You can do the same if you like. It's completely free to do it this way. And it gives you a chance to get into blogging and test the waters a bit before you go "Pro" with your blog.

Online marketing is all about content marketing. That means that you must teach something that is related to your subject.

For instance, if you are a watercolor artist, you could teach others all that you know about watercolor painting. I go into a lot of detail about this in Chapters 1 and 2.

2) Email Newsletters

Email newsletters are an important part of this plan. The information in Chapter 3 will show you step-by-step how to set up and operate a successful and profitable email newsletter.

An email newsletter should have an educational aspect to it just like your blog. It should teach your readers something. It should educate them about a topic that is related to your blog. For instance, if you are a photographer, one of your email newsletters could be about helping new photographers learn all about cameras and photography. If you are a graphic designer, one of your newsletters could be about helping modern design students learn the ropes of graphic design.

Are you starting to get the idea?

3) Social Media

Social media is an important part of this plan. Making **real** social connections through sites like Facebook, Instagram, and others can have a lasting impact on your success. The information in Chapter 5 will show you how to integrate social media into your overall plan. They will show you how to drive massive amounts of free traffic to your blog using social media.

4) Webinars, Online classes

Webinars and online classes are an important part of your presence online. Webinars help you to build a more intense connection with your customers. They help you to connect in real time, which is vitally important to building online success.

5) Fine Art Gallery

Your fine art gallery is the part of your blog where you showcase your artwork. Once you have your blog set up, you will want to create a gallery of your work there. You should consider showcasing original artwork as well as reproductions in your online art gallery.

6) Art Information Products

Art information products are an important part of this plan. These products include eBooks, reports, audio files, video files, and other products that can be sold as instant downloads. These kinds of products are important to your success when selling online. In fact, many of products successfully sold online come from this category. Chapter 5 will give you ideas on how to integrate these types of products into your sales funnel.

Exercise 1

Before you begin reading the chapters in this eBook, I want you to do an important exercise. I want you to think about and write down some topics for newsletters and blog categories that will be on your site.

What are you most passionate about? What do you know that you could teach to others? What would you enjoy teaching to others?

Here are some examples:
If you are an oil painter, you could teach others all about oil painting. You could help others understand color theory.

If you are a watercolor artist who loves and makes paintings of flowers and gardens, you could teach others all about flowers and gardening. You could take your love of this subject and turn it into a "how-to" guide for gardeners. You could also teach lessons on the art of painting flowers.

If you are a landscape painter, you could take your love of the outdoors and write blog articles and a newsletter about the beauty of your country's national parks.

Your blog and newsletter could focus on how to make a home warmer and more inviting with art. Your articles would be all about beautifying and enhancing the home with art.
If you paint pet portraits, you could take your love of pets and write blog articles and a newsletter all about pets. You could write all about cats or dogs and how to care for them in the proper way.

If you are a sculptor, one of your email newsletters could be about helping new sculptors learn all about the methods and materials of your craft.

If you are a graphic designer, one of your newsletters could be about helping modern design students learn the ropes of graphic design.

These interests and passions that you have will translate into categories on your blog and themes for your emails newsletters.

Chapter 1 - How to Become a Pro Art Blogger

Before we get started with the technical aspects of setting up and getting going with your art blog, I want to address one key issue that holds a lot of people back–Fear.

The beginning of this chapter helps you face and overcome your fears of writing or blogging. You may not like to write, or you may think that your writing is not good enough. Or maybe you think you just don't have the time to sit down and write. That's okay. You can still be a Pro art blogger.

Starting an Art Blog: What If You're a Terrible Writer?

Are you thinking about starting an art blog or email newsletter? Are you worried that your writing skills may not be good enough?

Let's face it, this is at the heart of why we put off getting that art blog or email newsletter going in the first place, isn't it? Or if we did get it started, we put off writing the kind of solid content that gets us where we want to be. We do link posts and fluff and re-hashes of someone else's relevant content.

Even the best writers face insecurity and anxiety when they sit down to write an art blog. And for a not-so-good writer, it can be even worse.

All that anxiety and brain damage does you no good. It won't give you the energy to be a better writer. It won't put fire in your belly. It just keeps you from writing. Or if you do overcome your nerves and get started, it makes your writing stilted and stiff.

Here are some tools and techniques to banish writing anxiety forever. You don't need that heartburn, so let's get rid of it.

Writing an Art Blog: Our Kind of Marketing is a Conversation

Blogging and Email marketing is part of a larger category called *content marketing*. The basic idea is that you provide a wealth of useful, relevant content to your prospects and customers, and they reward you with their trust and their business.

By far, the most rewarding way to approach this strategy is as a **conversation**. Now I realize it's a little one-sided, but think of your messages has half of a conversation with your customer, even though usually you won't be able to hear the other half.

Think about your ideal customer. You're going to speak directly to her. You've invited her for a coffee and a nice chat about what's new. You'll give her a little bit of useful advice with your cookie content and you might let her know if you've got something on the shelves you think she would enjoy.

One of the nicest things about this "conversation" angle is that you can and should **write like you talk**. You're not creating a college essay. You're not writing a job application. You're not writing to impress someone or receive a grade.

You're writing to make a nice, friendly connection.

"Conversational Grammar" is Perfectly OK

Here's the great, Wizard-of-Oz secret about writing marketing content:

It's perfectly fine to make grammar mistakes in your art blog or email newsletter. Spoken language follows slightly different rules from formal, written language. The stuff we learned (or failed to learn) in 5th grade were the rules for written English. They helped us get decent grades and go to college. They're important if you want to write a book, or an article in *The New Yorker*.

They are not important for your art blog or email newsletter. I hereby give you permission to never spend one second worrying about whether the language in your art blog or email newsletter is "correct." That's not what matters

(This is not easy advice for me to give. I'm a grammar dork. I read books like *Eats, Shoots and Leaves* for fun. But this is something you need to know, so I must control my own Grammar Cop tendencies and give you the straight dope.)

Clarity, Not Correctness

Clarity is king in your art blog and email newsletter writing. Your readers must understand you before they can really form a bond with you. If your writing is grammatically perfect but hard to understand, you have a major problem.

On the other hand, if your writing is completely clear and conversational, even if the grammar is a little "colorful" in places, you've done a terrific job.

Become obsessed with clarity. Take long-winded sentences and cut them into two or three parts to make them easier to read. Take out anything "clever" if it could also be confusing. Use a tool like the Flesch Reading Scale to analyze the grade level of your writing. If your email newsletter reads at a 5th grade level, believe it or not, it's just about perfect.

(The eBook you're reading now came in at 5.5 to 6th-grade, so I feel pretty good.)

It's not that your readers are dumb—they're not. But they're *busy*. Even if they have multiple PhDs and read about nuclear physics for fun, they're looking for an easy, enjoyable read when they open your newsletter.

Keep It Simple, Sweetheart!

How to Write an Art Blog Even if You Hate to Write

Are you thinking about starting an art blog or email newsletter? But are you hesitant to start because you hate to write? Or are you afraid you don't have time to write?

Let's face it, this is at the heart of why we put off getting that art blog or email newsletter going in the first place, isn't it? Or if we did get it started, we put off writing the kind of solid content that gets us where we want to be. We do link posts and fluff and re-hashes of someone else's useful content.

Even the best writers face insecurity and anxiety when they sit down to write an art blog. And for a not-so-good writer, it can be even worse.

All that anxiety and brain damage does you no good. It won't give you the energy to be a better writer. It won't put fire in your belly. It just keeps you from writing. Or if you do overcome your nerves and get started, it makes your writing stilted and stiff.

Here are some tools and techniques to banish writing anxiety forever. You don't need that heartburn, so let's get rid of it.

Writing an Art Blog: The Faster, Easier Way

Does the thought of sitting down at that keyboard make you sick to your stomach? No problem at all.

There is a terrific service called SpeakWrite. You might start by scribbling a few rough notes about your topic, to collect your thoughts.

Then you call the service on the phone and just say what you want to say. Remember, it's a conversation–pretend you're recording a voicemail message for one of your customers.

SpeakWrite transcribes your message and emails it back to you, typically within 2 hours. The charge? 1.25 cents a word for general, non-legal work. That's $1.25 for every 100 words.

The chapter you're reading today would have cost me less than $7 to dictate and transcribe. When you start to realize how much time you can save, that is wonderfully cheap.

There's also software that can do this for you. The one most people use is called Dragon Naturally Speaking. If you love this technique, it may be worth the investment (in both money and time—you need to "train" the system to recognize your speaking voice). It's sold on Amazon and at most software vendors.

A lot of the major "Internet guru" marketers use this technique, not necessarily because they don't like to write, but because it saves a huge amount of time. 20 minutes of speaking is about 8 pages, which can easily take 3 to 4 hours to write.

Not only that, the writing is more fluid, because it comes directly from the spoken voice. Now I love writing and I still believe it has value. But if you don't write for the love of it, give these dictation tools a try. I think you'll find they transform your writing dread into excitement and enthusiasm.

Getting Your Art Blog Headed in the Right Direction

Have you ever thought about what was at the heart of a successful art blog? Have you ever wondered about the real essence of an art blog, what are the guiding and underlying principles that will make it a true success?

A lot of artists out there trying to start up their art blog and art website get this all wrong. I see it all the time. I look at a lot of art blogs and art websites. Every day artists write me and ask me to look at their websites or art blog. And I try to look at everyone.

What I see when I look at a person's new art blog or website always makes me think. I think about how the first inclinations that you have when you go to put up your art blog or art website are usually all very wrong.

What do I mean?

Your first inclinations, like mine were in the beginning, are to make the blog all about you. You get all excited and pumped up thinking that you are going to become a celebrity. **And all you can think about is getting the show on the road, telling the world everything you think they want to know about you.**

I remember when I first started this art blog. I was excited. I was going to tell the world all about Me. It was going to be: ME, ME, ME, ME!!!!!!!

But luckily, before I really got going, I did some research and reading about blogging. And luckily, I changed my tune before I got too far along.

Nothing will sink your art blog faster than just blogging about yourself, your latest paintings, your newest work, the skiing trip you took last week.

Why? Because unless you're a famous movie star like Brad Pitt or Angelina Jolie, nobody cares about you personally. Nobody cares about your newest paintings, or what you did last Thursday. Sorry to burst your narcissistic little bubble, but I'm trying to tell you the truth here.

Secrets of a Successful Art Blog You Only Get to Keep What You Give Away

So, what is the real essence of a successful art blog? Giving stuff away, and I'm talking about mainly information here.

You give and you give and then you give some more.

Specifically, what kind of information do you give away? You give away everything you've got stored up there in that big, beautiful brain of yours.

You **give away** stories and articles that **educate** and **entertain** your audience. You share and give away all your most cherished secrets concerning your craft or art form. You tell us your secrets how you paint what you paint, or sculpt what you sculpt. You give us the secrets how you have become the success that you are today.

If you're a photographer, you give away everything you know about cameras. If you're a graphic designer, you give away everything you know about your tools and your craft.

Does this make sense?

In the final analysis, it's all that really matters. **It's how much you give away that will finally equal how much you get to keep in loyal readers, subscribers, and sales.**

Always remember this main key to blogging success: You only get to keep what you give away.

How to Sell Art Online: Case Study

There's a saying in marketing: "There are riches in niches." If you want to successfully sell art online, your goal is to correctly identify, target and dominate a specific niche.

What is a niche?

A niche is simply a group of people who share a common interest or a common set of characteristics. For example, if you play tennis, you belong in the niche of people who love tennis. If you are a housewife between 28 and 35 years of age, you could be classified into a niche. If you are a watercolor artist, you belong in the niche of people who love to paint in this medium.

You must target a specific niche to succeed on the Internet. A lot of artists out there with blogs and websites are getting this all wrong. They put up a static website or a general art blog or put their art on group sites like eBay or Etsy, hoping to attract a broad audience. And they wonder why no one ever shows up to buy anything.

On the Internet, you can't succeed going after a general art audience, expecting to capture everyone. In marketing, you have the shotgun approach and then you have the rifle approach. **As an art blogger with an internet art business, you must use the rifle approach, aiming a single rifle shot at a narrow audience.** Leave the shotgun approach to large corporations like McDonald's or Exxon who can afford to do it well.

Let's look at a case study to see how to find and sell art successfully to a very specific niche.

Case Study: Selling Horse Sculptures Online

An artist from Sweden recently contacted me about his online art business. He had spent a lot of time and money on a website, but wasn't seeing any return for his efforts. He was very disappointed in his online venture and about ready to pull the plug on the floundering business out of complete frustration.

He contacted me to learn how to correctly sell his art online and save his internet art business.

I did a thorough assessment and evaluation of his website and online art business. I also made very specific recommendations and helped him to put these into action.

Here is some of what I uncovered about his online art business:

This artist was very talented and made high quality bronze sculptures of horses. These beautiful sculptures reminded me of the work of the famous American Western artist Frederic Remington. They were about the same size and quality of work. **The quality of the artwork was not the reason for the failing art business.**

This artist had a beautiful static website to sell his sculptures. It was well-designed with a beautiful gallery showcasing his bronze horses. He had an efficient and professional check-out system to process sales. **The quality of the website was not the reason for the failing art business.**

All in all, his website was professional and looked great. But he wasn't getting any sales online. He wasn't even getting any traffic or any inquiries from the few people who did show up. His marketing strategy was too simple to be effective. Basically, he had just put up a website like a big billboard in Cyberspace, hoping to attract everyone and anyone.

His website, although beautiful and professionally designed, was failing miserably.

Here's the fix for this struggling online art business:

So, what was wrong? One thing. His marketing approaches. **He wasn't attracting the very specific audience or niche that he needed.**

So, what did I suggest he do to turn things around and make the site a success? I suggested that he should start a blog.

Now, should he blog all about himself and how beautiful his sculptures are? NO. Absolutely not. If he only blogs about himself and his latest projects or newest work, no one will ever be interested enough to read it. Why? Because no one cares about him personally. This is the wrong approach for his blog. If he blogs only about himself and his latest work, his blog will be a failure just like his static website was a failure.

So, what is the correct approach here? What should he blog about?

He should blog about horses. He should blog all about how to make horses happy and healthy. He should blog about everything he knows about horses. If he sculpts horses, he loves horses, and that means he probably knows an awful lot about horses. Right? I told him he should take his love of

horses and his vast knowledge of horses and share it with the world.

So, who is he going to attract with his blog about horses? He is going to attract horse lovers. He is going to grow a large following of avid horse lovers. He is going to connect to a large family of like-minded people who love the same thing he loves. These horse lovers will subscribe to his blog and to his email newsletter to learn more about horses from him. These are the perfect people, the perfect niche to buy his horse sculptures.

Who better to buy sculptures of horses than avid horse lovers?

So, this artist should blog about horses. And then in a very balanced way in his blog and newsletter, he will make offers for his horse sculptures. Do you see how this works? Following this marketing strategy could easily net this sculptor a six-figure income from his blog and website each year. He could dominate this art niche by passionately sharing with the world his

love and knowledge of horses. In time, this website and blog could be worth millions of dollars. This case study is a perfect example of correctly identifying and targeting a very specific art niche. Correctly identifying the perfect niche for your art products is crucial for your online success.

Here's a Few More Ideas....

Sometimes the niche is not as easy to find as in this case study. So, brainstorm as many ideas as possible. Get together with a group of your artist friends and have a brainstorming party. In the meantime, here's a few more ideas that will get you going in the right direction.

If you paint pet portraits, then blog all about pets. Blog about dogs and cats and pets in general, how to keep them happy and healthy. You will attract pet lovers who will almost certainly want a portrait of their beloved pet.

If you paint or take pictures of flowers and gardens, then blog about flowers and gardening. Blog about how to raise prize roses or grow bigger and better tulips. These garden lovers will almost certainly want pictures of gardens and flowers in their homes.

You can also blog about how to make a home more beautiful with art. You could become the "Martha Stewart" of home decorating with the focus on art. I have used this niche very successfully. I call the category "The Artful Home." What niche does this blog attract? It attracts housewives who are in the age group from 35 to 55 years of age. These housewives want their homes to be warm, cozy and inviting. Art is the perfect pitch for them because it fills this basic need.

And, of course, you could always teach lessons on how to paint or photograph or sculpt, whatever it is you do. You could share

with the world all the knowledge and ability you have acquired over the years. Teaching art lessons online is a great business strategy. Your students will want your eBooks and other art information products to help them become the best artist they can be. And your loyal students will also want to buy your original art.

Art Blog, Group Art Site, or Personal Art Website? Which is Better?

Have you been thinking about joining the growing ranks of artists online? But are you confused about which direction you should take on the internet?

There are lots of directions you can take when it comes to promoting your art on the internet. Some artists go with a group art site like Etsy, eBay, or Art in America Mall. Other artists create a personal website. And some artists start an art blog.

But which of these directions is the best when it comes to selling your art online? Have you ever given it much thought? Which of these choices will lead you to a truly successful and abundant artistic life on the internet?

These are excellent questions to think about when you are trying to promote your art online. But sadly, most artists never give these questions much thought. They just forge ahead without much of a marketing strategy at all.

And sadly, most artists will fail online. **It's sad but true, 97% of all online art businesses will fail in their first year.**

So, let's look at each of these choices and see which is the best, which will give you your best chance to succeed online.

Group Art Sites

There are many, many group art sites online. In fact, there are too many for me to list here. But you probably know most of the major ones, sites like Etsy, eBay, Art in America Mall, and Absolute Arts.

Many artists flock to these group sites hoping to strike it rich on the internet. They think that the huge traffic that comes to these sites every day will translate into name recognition and sales for them. But sadly, this is rarely the case. **In fact, group art sites are the worst place to grow your online art business.**

Why I don't Like Group Art Sites.

There are 2 reasons I don't like or recommend group art sites.

The first and foremost reason is that you are digital sharecropping. What is digital sharecropping? It simply

means that you are building your online art business on somebody else's land. This is never a good long-term strategy.

Think about it for a minute. When you build your hard-earned art business on somebody's else's land in Cyberspace, you are setting yourself up for all kinds of problems in the long haul. These sites can and often do change the rules. Lots of times these frequent rule changes play havoc with your business.

You are not master of your own universe because somebody else is making the business rules. Your business is at the mercy of someone you don't even know.

Also, these sites can go out of business or become extinct overnight. Remember MySpace? If they become extinct or less popular, you will too. **Never tie yourself to the fate of another business.**

The second reason is that it makes you look like a commodity. The last thing you want to be when you are an artist is a commodity. Commodities often sell for the lowest prices.

This is the sad truth about group sites: everybody looks the same and so the sell goes to the lowest price. **Pricing on these group art sites always spirals downward as artists try to compete for the next sale. Anybody can lower their prices and go out of business. Live by the low price, die by the low price.**

Personal Art Website

Personal art websites are better than group art sites but they are not the best choice. Why? Personal websites, also known as static websites, are just that, they are static. They usually just have a few pages that do not change very much or very often.

Because your site is static, first-time visitors don't have much of a reason to return or keep coming back. They see it all on the first visit and then click away never to return. And they forget about you very, very quickly.

It's very difficult to make a static website interesting enough to keep visitors coming back.

Search engines, especially Google, are not that crazy about static websites and so they often don't get indexed well. This means fewer visitors to your site over time.

Art Blog

An art blog is the best way to promote your art and art brand online. Why?

An art blog lets you be master of your own universe. When you have an art blog with your own dot com address, no one can tell you what to do or what not to do? You make all your own rules. This is the best long-term strategy for growing your art business.

Also, an art blog allows you to create fresh, quality content on a regular basis. Fresh, quality content means readers will keep coming back for more. And search engines love fresh, original, quality content. An art blog that provides this will automatically keep moving up in the search engine index ratings. This means more daily traffic to your art blog, not only from organic search traffic, but from returning readers who want to learn more from you.

Hands down, the best direction you can take to grow your online art business is an art blog. For my money, nothing better will give you that leading edge and put you in that 3% of artists who will finally share the big money pie online.

A Few Words about Naming Your Blog

I suggest that you use **YOUR OWN NAME** for your blog. For example, I use my name Gary Bolyer for my domain name www.garybolyer.com. You could also add Fine Art or Art Studio to your name.

For example, Gary Bolyer Fine Art (www.garybolyerfineart.com) or
Gary Bolyer Art Studio (www.garybolyerartstudio.com). That's okay, just as long as YOUR NAME is in the first part of the name string.

Using your own name helps to promote YOU as the artist and create name recognition for YOU as the brand. Building NAME recognition is very important for an artist on the internet.

If you've already created and named your blog and you've decided that you don't like it, that's okay. You can always change the name later when you go to get your own domain name and become self-hosted. All of this is explained in future lessons in this course.

How to Design Your Art Blog Posts Like a Pro

Do you know the one skill that you have as an artist that will really help your art blog succeed? It is your artistic design

skills. Because you are an artist, you are already way ahead of a lot of other people out there who are blogging.

Why?

Because a successful blog is all about design. And as an artist, you are well-trained in design. Whether you are a self-taught artist or have an art degree from the best art school, one thing is clear. You know how to design. And this is very important to the success of your art blog.

When it comes to designing the blog posts, I'm not talking about the design of your blog. When you first setup your blog, you designed it by picking out your theme and making other decisions, such as the header picture, etc. These decisions stay fixed. What I'm talking about is the design you must do within each blog post itself.

In other words, the body of text that you write each time you write a new blog must be designed correctly. It can't be just a big block of text with lots of paragraphs that ends up looking like a wall of words.

Why do you have to carefully design each blog post? Because people don't read a blog post, they scan it.

People Don't Read, They Scan

This is the most crucial point in this lesson. If you don't remember anything else, remember this: People today are too busy to read, so they only scan.

People in today's competitive and busy world just do not have the time to read a large body of text. It's almost like they have Attention Deficit Disorder on steroids. So, your blog posts can't read like a novel or a book, with lots of long paragraphs and blocks of texts. In fact, you are not writing a book or novel here. You are blogging, which is vastly different.

Most people who land on your blog post will stay there less than 1 minute. The vast majority will leave after 5 to 10 seconds. The reader who lands on your blog page will decide in less than 5 seconds whether they want to scan your blog and stay longer. So, what does that mean for you? You must make your blog posts easy to scan. How do you do that?

How to Make Your Blog Posts Easy to Scan

Making your blog posts easy to scan is simple when you use your artistic design skills. One element that is very important in artistic design is the use of white space. Using white space in your blog is very important.

Always use lots of white space. Break paragraphs into 1 to 5 short sentences. And always space between paragraphs.

Most sentences should be very short and easy to read. If you are in doubt about using a very long sentence with 2 or 3 commas, break it into 2 or 3 shorter sentences instead.
Use lots of headings and subheadings. Use bullets or numbers for key points. Use bold text for key points and to highlight the most important ideas.

Use a summary at the end to highlight key ideas. **Make it very easy to see the important ideas and scan them in less than a minute.**

Write at least 300 words

Each blog post needs to be at least 300 words. It can be longer, of course, if it is designed well using the ideas in this article. But don't post blogs less than 300 words. Why? The search engines, especially Google, will not index blogs less than 300 words.

There is an upcoming lesson in this course that will help you optimize each blog post for the search engines. So, I'm not going into detail on search engine optimization (SEO) in this this article. Be on the lookout for that future lesson.

For now, just be aware to write a minimum of 300 words. Okay?

Always Add At least One Picture

Pictures add a lot of interest to your blog post. They help your blog post look well-designed and professional. People will stay longer to look at an interesting picture and read the caption, which might hook them and lead them to read your entire article. So always use pictures.

Always add at least one picture to each blog post. You will need a picture to add an alt tag (alternative text tag), which gives you a big, big boost with the search engines indexing your blog post. Again, this is all covered in a future lesson on SEO for your blog posts.

Add captions to your pictures to add more interest and to repeat important key points.
Use text wrap to wrap the the text around your picture. Look at the picture in this post. See how the text wraps around the picture. This is a fitting design element and makes you look professional.

If you use more than 1 picture, use your design skills to make the pictures come alive on the page. Experiment with using pictures of varied sizes and alternating them from the left side of the text to the right. Or you might try centering the picture instead.

Where do you get pictures and images? There are lots of free places to get pictures and images on the internet. Usually, the free websites will say "royalty free" images. There is no charge for using a picture from a royalty free site.

For instance, let's say you are writing a blog post about apples. And you want a free picture of an apple. Just go to Google or Yahoo and type "Free picture of an apple" into the search bar. Lots of choices will come up. Sometimes the artist or photographer of the apple will post their name. If they do, you may give them credit for the picture in the caption. But most times this is not necessary.

Summary of Key Ideas for Designing Each Blog Post

Take a moment to look briefly at this blog post and see how it is designed with lots of white space, bold text, a picture, bullets, and headlines.

Make your blog easy to scan and you will always be rewarded with lots of readers.
- Use your artistic design skills to design each blog post
- Use lots of white space
- Make paragraphs only 3 to 4 sentences each
- Always space between paragraphs
- Use bullets for key points
- Use bold text for important ideas
- Always add at least 1 picture
- Use headings and subheadings
- Always space between headlines and paragraphs and add a summary of Key ideas at the end

Two Tests to Predict Art Niche Success

There's a saying in marketing: "There are riches in niches." This lesson is all about identifying and honing in on the niches that are most likely to lead you to your own art blog riches.

In Exercise 1 of the Course Overview The_Big Picture, I suggested that you begin making a list of several topics that you were passionate about. This list of topics are the things that you are most interested in sharing and writing about on your blog. I asked you to search your heart and soul and come up with ideas that you are most passionate about.

In Exercise 2 of this lesson, you are going to take that list of topics and ideas and test them to make sure that they are practical subjects for a blog. What do I mean by "practical"? By practical, I mean that they are topics that have the best chance of succeeding on the internet.

There are two tests. Test 1 determines if your market niche is big enough. Test 2 determines if there are enough people in your market niche willing to spend money on your topic.

Does this make sense? This information is very important to the financial success of your art blog. If one of your topics does not pass the tests, then you should probably abandon that idea for one that tests more positively. A topic that does not have a large enough audience or an

audience who is not willing to spend any money may not generate the kind of success you want for your art blog.

There are two tests that you should do on each topic or subject idea. The first test is the Google Keyword Tool Search Test. This first test makes sure your internet audience is large enough.

The second test is the Competition Test. This second test makes sure that there are other people out there who are already making money with the idea or topic you are considering.

Both tests are very important. Do not go ahead with developing a topic further unless it passes BOTH tests. REPEAT: An idea or topic MUST PASS BOTH TESTS to be a truly worthwhile or practical topic, one that will be successful and generate profits for your art blog.

Are you clear on this? I strongly suggest that you choose ideas for your art blog very carefully, only after applying this basic research. If a topic does not pass both tests, then please go ahead to the next topic in your list until you find one that passes both tests.

Okay, are you clear about all this so far? So, let's get to testing your ideas.

Test 1: Google Keyword Tool Search

This test is very simple and easy to do. Use the Google Keyword Tool (just google this name). Once you are on this page, you will do a search for the first or most passionate topic on your list.

Let's say that you have picked How to Paint Still Life in Watercolor as the topic for your art blog. You will type in this whole phrase into the search tool. It will return the number of searches that are performed each month on this topic. Let's say that this phrase returned 7,000 searches per month.

You may also try some related phrases that the Keyword Tool suggests such as, Watercolor still life painting, painting fruit in watercolor, how to paint an apple in watercolor, etc. You find that these related searches total 5,500 searches each month.

This makes the total searches each month for your topic 12,500. This total number of searches each month is too small. The audience for this topic or subject is not large enough.

A topic (and its related keywords) needs to have at least 40,000 searches per month to be considered large enough.

Red Flag: If a topic and its related keywords do not have 40,000 combined total searches each month, then this market niche is too small.

Let's continue with our example. After reconsidering your topic, you decide to go after a broader niche market but within this same theme. You now try a new keyword search with the phrase How to Paint in Watercolor. This returns 22,800 searches per month.

You now search some suggested related terms such as How to Paint Landscapes in
Watercolor, How to Paint Still life in Watercolor, How to Paint Seascapes in Watercolor, How to Paint Flowers in Watercolor, Painting Portraits in Watercolor, Pet Portraits in Watercolor, etc. You find that these related terms return 33,000 searches per month.

This gives you a grand total of 55,800 searches per month for your main topic and its related keywords and phrases (22,800 + 33,000 = 55,800). Bingo. You have hit the jackpot. This internet audience is certainly big enough.

So now let's go ahead to test two.

Test 2: Competition Test

In this test, you are going to go to Google Search, Yahoo Search, or Bing Search and type in your phrases or keywords. You are looking for competition. You are looking for other people who are already set up and doing what you intend to do with your art blog.

In this case, the more competition you find, the better. That's right, you are reading this correctly, the more competition you have, the better. Why? It simply means that there are lots of

people out there already making money with this idea and that is a good thing. It means, then, there are lots of people out there willing to spend money on your topic.

Let's continue with our example of How to Paint in Watercolor. Let's say you do a Google search for this topic and find lots of people who have internet sites and are selling their watercolor products. You find that there are watercolor artists selling How-to books on watercolor painting. They are also selling internet classes and webinars on how to paint in watercolors. They are also selling their watercolor paintings, prints, and reproductions from their art galleries online

This is a very good sign. This means that this topic has passed Test 1 and Test 2. This topic would certainly be a successful one to pursue as your blog subject.

But what about the opposite? What if you find very little or no competition for your subject or topic.

If you find very little or no competition for your idea, it means that there is probably no one out there willing to spend money on your idea. You may want to reconsider your idea for one that could potentially be more profitable.

Red Flag: Lack of competition in a market niche means lack of paying customers.

Here's a simple example. Let's say your topic involves teaching internet classes on caste ceramics. You do a Google Search and find that there is no one else teaching internet classes or selling eBooks on how to make and fire cast ceramics. This is a red flag. It could mean no one is willing to spend money on eBooks or internet classes to learn to make and fire cast ceramics.

Exercise 2

Now you are ready to start applying what you have learned from this lesson. This exercise is very important and could help predict the success or failure of your art blog.

Take each of your ideas that you brainstormed from Exercise 1 and apply them to the tests above. Put them through Test 1 and then through Test 2.

If an idea or topic passes both tests, then it will have a higher chance of succeeding over time as your blog subject. I strongly suggest that your idea or topic must pass BOTH tests before you go ahead with further development on your blog.

If an idea or topic passes one test but fails the other, then I strongly suggest that you find another idea or topic. Simply go to your next idea and test that one. Test ideas until you find one that you are passionate about that passes BOTH tests.

Using Yoast for SEO

Do you know one of the best things about a blog? Blogs attract Search engines like flowers attract hummingbirds.

Why?

Because search engines love blogs. Each time you write a blog post, you are creating keywords and long tail keyword phrases that will be indexed by the search engines. Whenever someone on the Internet types in your keywords, your indexed blog post will come up in their search results.

This is how you get lots of free traffic to your blog. And this traffic is very targeted, because they are very interested in the topics you are writing about.

In this section, you are going to learn how to greatly improve your WordPress blog's SEO.

How? By using the free Yoast plugin.

What is Yoast and What is a Plugin?

Yoast is a third-party company that specializes in Search Engine Optimization (SEO). They have a Free plugin that will help your blog posts rank higher in Google search. As you use the Yoast plugin, you become your own SEO expert.

What is a plugin? A plugin is simply a short piece of code that performs a specific job. These are sometimes also called scripts. Plugin's are great because you don't need any specific skills to use them.

You don't have to be a programmer or know anything about writing code. You just download the plug-in and it starts working on your WordPress blog immediately after you activate it. And there are thousands of free plugins that will perform thousands of free tasks on your blog.

How to Download Your Free Yoast Plugin

Loading your own free copy of the Yoast plugin is very easy. Go to your WordPress blog post editor. Scroll down the left sidebar until you come to **Plugins.**

Hover your mouse over **Plugin** and select **Add New**. Go to this page and in the **Search box** type **Yoast.** Select

download plugin. Once Yoast is downloaded, select Activate plugin.

What About Using Keyword Tags?

In your WordPress blog, you have an area in the editor which allows you to add keyword tags, which is different from the focus keyword or phrase in Yoast.

The Yoast plugin helps you create a focus keyword or phrase for your blog post and then structure the blog post around that keyword or phrase. Google Search will use this focus keyword or phrase only to index your blog post.

Google no longer uses keyword tags.

But I suggest that you go ahead and use the Keywords Tags. Google may no longer use them, but other search engines like Bing and Yahoo still do. So, you will still get some traffic from adding the Keyword Tags each time to your blog post. The Keyword Tags are found in your blog post editor along the right-hand column. It only takes a minute to add five or 10 keyword tags that are related to your blog post. And that's all you need here.

Write to One Person

If your computer dies and you never receive another lesson, this one tip alone will put you in a different league from your competition.

The first step is simple, but not always easy. Decide who your perfect customer is. (Keep in mind that for your project, a "customer" might be a nonprofit donor, a fellow blogger who adopts your ideas, etc. A customer is just a person you have motivated to act.)

Now you may have a perfect customer now. Maybe you've got an individual who refers lots of business to you, buys everything you put out, and brings your employees flowers because he loves you so much.

If you're not lucky enough to have a customer like this, you'll have to use your imagination. What would that kind of customer look like? Male or female? How old? Where would she live? What does he drive? Kids? Grandkids? Family oriented or party animal?

There is a saying in marketing: "You want to breathe the air of your customer." In other words, you want to know as much about your ideal customer as possible.

Don't just do this exercise in your head—write down every detail. Keep a running list, and add to it as innovative ideas come to

you. If you have a trusted business partner, or a friend or a spouse who really understands your business, share your portrait with that person. Does it ring true?

A surefire way to find out more about your ideal reader and customer is by polling or surveying her. There are free plugins on your WordPress site that allow you to create a poll or survey. Download a poll plugin on your site and create a poll. Ask for the age, gender, income, marital status, etc.

Then write a blog post and add the poll to it. The headline of the blog post could read, "Can you do me a favor?" Ask her to help you out by answering a few questions. This is a wonderful way to get to know who your ideal reader and customer is.

Always Write Directly to That One Person

In marketing jargon, you've created a "persona" or "avatar." Give your avatar a name, to make her even more real to you.

Then write everything directly to that person. Imagine her sitting across from you in a coffee shop, as you share news with her about what's going on in your business.

(By the way, in most industries—including some you might not think, like electronics and auto purchases—women make more purchasing decisions than men. Only you know for sure in your own business, but think seriously about making your avatar female.)

If your ideal customer is a little formal, write to her like you'd send an email to your Great Aunt Susie. If he's casual, write like you'd write to an old college buddy. (It's probably smart to keep it rated-G, though.)

Your ideal customer isn't just a customer, she's a friend. Write warmly and directly to her. Every time you put your fingers on the keyboard, visualize that friendly, caring face. Use "You" and "Your" as you talk directly to her. Don't use "We" and "Us" like you are talking to a group.

Don't Get Distracted

You will be tempted to write for your other customers, too. You'll feel like you're leaving someone out. This feeling may induce a little panic—your business can't afford to leave any money on the table by "ignoring" some customers.

Talking to a group is a mistake that will cost you a lot of money. Don't do it.

Keep yourself laser focused. By writing directly to that one ideal customer, you'll automatically find all the customers who are on the perfect wavelength for you. Even if they look a little different from your "avatar," the personal, genuine way that you write is going to bridge that gap naturally. You'll take customers who could be ideal, and make them ideal. You'll create a memorable, heartfelt connection. You'll find your raving fans.

You'll create a referral and repeat business engine that will propel your business to success. Until you receive your checklist at the end of the course, get up right now and write up a Post-it for yourself.

"Write to One Person."

Stick it on your computer, and maybe an extra copy or two around your office or someplace else where you'll see it often.

It isn't always easy. But any of us can do it if we keep working at it, and you'll find that it transforms your business.

How to Write Eye-catching Headlines that Transform Browsers into Buyers

Want to write great headlines and even better content?
Do you want more readers for your email newsletter or blog and more buyers for your products?

Start with the headline first.

Picture your blog post being retweeted thousands of times on Twitter, and shared all over Facebook. By the time you finish reading this article, you'll be in a better place to make that scenario a reality.

The biggest battle is getting enough people to read in the first place. And that battle is won or lost at the headline.

Your headline is the first, and perhaps only, impression you make on a prospective reader. Without a compelling promise that turns a browser into a reader, the rest of your words may as well not even exist.

So, from a copywriting and content marketing standpoint, writing great headlines is a critical skill.

Here are some interesting statistics…

On average, 8 out of 10 people will read headline copy, but only 2 out of 10 will read the rest. This is the secret to the power of your title, and why it so highly determines the effectiveness of the entire piece.

Remember, every element of compelling copy has just one purpose — to get the next sentence read. And then the sentence after that, and so on, all the way down to your call to action. So, it's obvious that if people stop at the headline, you're already dead in the water.

The better your headline, the better your odds of beating the averages and getting what you've written read by a larger percentage of people.

Once you understand why magnetic headlines pull readers in, you'll know how to do it for your own sales pages, every time. Follow along with me for the next ninety seconds and I'll show you exactly how you can turn a casual browser of your sales page into an avid reader, curious to drink in your copy until ultimately hitting the "Buy" button.

Tell your readers' they're in the right place
To stop readers in their tracks, capture their attention through every word of your copy, and persuade them to click that "Add to Cart" button without a second thought, you need to master the "headline reading psychology" of your soon-to-be customers.

So many people create clever turns of phrase hoping to pull people into their sales copy and wonder why their catchy headlines just don't work. The answer is simple: Readers are busy people, and they don't have time to study your sales letter to see if it's relevant to them. Instead, they rely on you to do that work for them.

But how do you do that? The answer to that is simple as well: You make sure your headline is clear, not clever, telling the reader exactly what your sales copy is poised to deliver.

Use specific keywords that show without a doubt that your page is relevant to people with a specific need or a specific problem – and don't over-think it. If you're a blogger, you probably already do this with your post titles, so apply that same thinking to your headlines.

For example, look at the title for this post – it's about "how to write headlines." Ever wonder why you always hear such high praise for "How To" headlines? It's because they're extremely relevant by nature. Keep in mind, however, that a "how to" headline might not be the most powerful choice for your sales page.

When it's time to write your headline, think of the primary problem or result your readers are after and make that the foundation of your headline. Do this right, and your readers will automatically know that they're in the right place – and save your cleverness for later.

Next, add the carrot: Attach a powerful result to your headline

After you set up relevance to your readers' immediate needs, you need to help your readers connect to a mouth-watering result that comes from addressing that need. The often quoted "How to _____ so you can _____" is a notable example of bridging relevance to result.

Never forget that your readers aren't looking for products or services – they're looking for beneficial outcomes, and the relevant keywords you write into your headline are often the means to that outcome. So, ask yourself why your readers want to take that relevant action, and you'll be guided to a promise _ or two that you can make in your headline.

I'll use this post as an example again – you're reading this far because you want to know how to write headlines, but what you're really after is getting people to buy from your sales page.

Finally, dress it up: Add emotionally stirring and action words to your headline

Once you've married relevance to outcome, it's time to add a little flavor to your headline by hand-picking compelling words to make those two features "pop."

In this post, I modified "headlines" with the adjective "eye-catching" to add some life to the text. I've also used the powerful transitive verb "transform" to suggest feasible change, which intensifies the promise of desired results.

Pick words that make the relevant keywords or the desired results seem more powerful and attainable – or simply add a third part to the headline like a time-frame or a variation of "easy" or "simple" (if it applies).

Take a few moments to read through headlines in magazine articles with a more educated eye, looking for how each example uses relevance, results, and powerful modifiers to make you want to read each article to the end.
Which, now that you think about it, you've just done with this article.

27 Proven Headlines That Will Sell Your Art (Or Anything) Like Crazy

Want to write great headlines and even better content? Do you want more readers for your email newsletter or blog and more buyers for your products?

Start with the headline first.

You'll of course have a basic idea for the subject matter of your blog post, article, free report, or sales letter. Then, simply take that basic idea and craft a killer headline before you write a single word of the body content.

Why?

Your headline is a promise to readers. Its job is to clearly communicate the benefit you'll deliver to the reader in exchange for their valuable time.

Promises tend to be made before being fulfilled. Writing your content first puts you in the position of having to reverse engineer your promise. Turn it around the other way and you have the benefit of expressly fulfilling the compelling promise you made with the headline, which ultimately helps to keep your content crisp and well-structured.

Trying to fulfill a promise you haven't made yet is tough, and often leads to a marginal headline. And a poorly crafted headline allows good deeds to go unnoticed.

You know, like your content.

"But that still doesn't tell me how to write a great headline," you're saying. No worries. That's what this part is all about.

1. The Power of the "How To" Headline

Picture your blog post being retweeted thousands of times on Twitter, and shared all over Facebook. By the time you finish reading this section, you'll be in a better position to make that scenario a reality.

It's no secret that "how to" articles and blog posts are some of the most sought after, linked to, and bookmarked content online. People want useful information, and they'll reward you by promoting it to others when you provide it.

The biggest battle is getting enough people to read in the first place. And that battle is won or lost at the headline. What's more, writing a killer "how to" headline will help you write even better "how to" content when you fulfill the headline promise you made to get people to read in the first place.

It's All About Benefits

The crazy thing about the popularity of "how to" content is the fact that people don't really want to learn how to do anything else.

They've got plenty to do already, thank you.

But it's exactly due to the crazy busy lives we lead that prompts us to seek out tips, tricks, and methods to make things better, easier, and ultimately happier for ourselves. Focusing on the "better, easier, and happier" is the key to great "how to" headlines and content. It's not that people aren't smart enough to understand the implied benefits of learning how to do something. It's quite the opposite. It's just that implied benefits don't prompt action like express benefits do.

People smartly employ aggressive attention filters when scanning headlines, and you'll get through the filters of a lot more people if you spell out the benefits rather than relying on implication. Plus, body content that focuses on benefits as well as procedures is more emotionally engaging, which leaves the reader feeling better satisfied after the piece.

It's been said that it's almost impossible to write a bad "how to" headline. That may be true, but what comes after those two magical words can make all the difference in the amount of attention and readership your writing gets.

Let's look at the structure of a few famous "how to" headlines, and see if we can't figure out why they work and adapt them to new situations and content.

Double the Benefits, Double the Power

This may be the most famous "how to" headline ever:

How to Win Friends and Influence People

Before Dale Carnegie's classic book "How to Win Friends and Influence People" was conventionally published, he sold it by mail order with that same title as the headline of the sales letter. Certainly, Carnegie's content was compelling, but that headline is brilliant all by itself.

The headline structure is powerful. You've got benefit number one right after "How to," with another benefit following the word "and." Simple, right?

Deceptively so, as copywriter David Garfinkel has pointed out. There is a subtle relationship between the first benefit and the second that suggests if you can achieve the first, you can automatically achieve the second.

In this case, that implication doesn't make sense — lots of people have friends and yet are completely lacking in influence. But that cause-and-effect relationship still likely helped Carnegie achieve greatness with his home study course, and later with the ubiquitous book.

It's much smarter from a credibility standpoint to use this structure when benefit one and benefit two are related. Here's a few examples that Garfinkel gives in his book:
- How to Save Time and Get Things Done (Time Management Coach)
- How to Get a Better Job and Make More Money (Recruiter)
- How to Save Money and Retire Rich (Financial Planner)

The dual benefit "how to" structure will always work if you logically link the two together and deliver relevant and substantive tips with your content. Give it a try.

How to [Mundane Task] That [Rewarding Benefit]
It's often harder than you might think to extract the true benefits of learning how to do something. Often, you can simply take a normal "how to" title and make it better simply by using the transition word "that" immediately following the subject matter of the tutorial. Once you add "that," just ask yourself what the top benefit of your tutorial is. Then figure out the best way to say it (which usually means being as specific as possible).

- How to Get a Mortgage That Saves You Money
- How to Get a Mortgage That Cuts your Monthly Payment in Half
- How to Get a Mortgage That Gets You in Your Dream Home While Saving You $937 a Month

Leaving Out the "To" Works, Too
Want to increase the curiosity factor of your headline, while just about guaranteeing that you'll nail the primary benefit of your tutorial? Start with "How" but leave out the "to." You'll still be making a beneficial promise to your reader that will be fulfilled in the content, but the intrigue factor will be higher and your results perhaps even better.

Let's look at these famous headlines:
- How I Improved My Memory in One Evening
- How I Made a Fortune With a "Fool Idea"
- How a New Kind of Clay Improved My Complexion in 30 Minutes

Those are intriguing headlines, right? Likewise, let's say you're a brilliant techie who has just solved a problem that affects millions of computer users, and you're aiming to light up Hacker News for a week.

How about this?
- How One Easy Tweak Makes Windows Crash Proof

Then again, that article faces the rather steep challenge of being impossible to write.

In Summary

The more you focus on the benefits to the reader in your headline, the more readers you'll have. And by touching on the beneficial aspects while laying out the procedural content, you'll have more happy readers after the piece. And then they just might retweet your article.

So, you're seeing too many of those "how to" headlines and want to try a few different angles?

Let's move beyond those common headline formulas you see over and over, and add some new blood to your attention-grabbing arsenal.

2. Who Else Wants [blank]?
Starting a headline with "Who Else Wants…" is a classic social proof strategy that implies an already existing consensus desire. While overused in the Internet marketing arena, it still works like gangbusters for other subject matter.
- Who Else Wants a Great WordPress Theme?

- Who Else Wants a Higher Paying Job?
- Who Else Wants More Fun and Less Stress When on Vacation?

3. The Secret of [blank]
This one is used quite a bit, but that's because it works. Share insider knowledge and translate it into a benefit for the reader.
- The Secret of Successful Podcasting
- The Secret of Protecting Your Assets in Litigation
- The Secret of Getting Your Home Loan Approved

4. Here is a Method That is Helping [blank] to [blank]
Simply identify your target audience and the benefit you can provide them, and fill in the blanks.
- Here is a Method That is Helping Homeowners Save Hundreds on Insurance
- Here is a Method That is Helping Children Learn to Read Sooner
- Here is a Method That is Helping Bloggers Write Better Post Titles

5. Little Known Ways to [blank]
A more intriguing (and less common) way of accomplishing the same thing as "The Secret of…" headline.
- Little Known Ways to Save on Your Heating Bill
 Little Known Ways to Hack Google's Gmail
- Little Known Ways to Lose Weight Quickly and Safely

6. Get Rid of [problem] Once and For All
A classic formula that identifies either a painful problem or an unfulfilled desire that the reader wants to remedy.

- Get Rid of Your Unproductive Work Habits Once and For All
- Get Rid of That Carpet Stain Once and For All
- Get Rid of That Lame Mullet Hairdo Once and For All

7. Here's a Quick Way to [solve a problem]

People love quick and easy when it comes to solving a nagging problem.

- Here's a Quick Way to Get Over a Cold
- Here's a Quick Way to Potty Train Junior
- Here's a Quick Way to Back up Your Hard Drive

-

8. Now You Can Have [something desirable] [great circumstance]

The is the classic "have your cake and eat it too" headline — and who doesn't like that?

- Now You Can Quit Your Job and Make Even More Money
- Now You Can Meet Sexy Singles Online Without Spending a Dime
- Now You Can Own a Cool Mac and Still Run Windows

9. [Do something] like [world class example]

Gatorade milked this one fully with the "Be Like Mike" campaign featuring Michael Jordan in the early 1990s.

- Speak Spanish Like a Diplomat
- Party Like Paris Hilton
- Blog Like an A-lister

10. Have a [or] Build a [blank] You Can Be Proud of

Appeal to vanity, dissatisfaction, or shame. Enough said.

- Build a Body You Can Be Proud Of
- Have a Smile You Can Be Proud Of
- Build a Blog Network You Can Be Proud Of

11. What Everybody Ought to Know About [blank]

Big curiosity draws with this type of headline, and it acts almost as a challenge to the reader to go ahead and see if they are missing something.

- What Everybody Ought to Know About ASP

- What Everybody Ought to Know About Adjustable Rate Mortgages
- What Everybody Ought to Know About Writing Great Headlines

You can write a headline in an infinite number of ways. However, certain types of headlines have proven themselves repeatedly for many years. By following the "formula" of these headlines, you can give yourself an edge when you are serious about persuading someone to read and respond to your copy.

The following 9 headline formulas are some of the easiest to write and the most powerful. When it comes time to write a headline, try one of these first. At the very least, this can give you a creative jumping off point to write a headline that works.

12. Say it simply and directly.
The direct headline should be used far more often than it is. No cleverness. No jokes. No wordplay. The direct headline gets right to the point. It works particularly well with strong offers, recognized brand names, and product or service types with which the reader is familiar.
- Pure silk blouses ... 30% off
- The Ultimate Tax Shelter •FREE subscription to BlogMaster

13. State the big benefit.
One of the first techniques you should always explore is transforming your major benefit into a headline. After all, your number one selling point should be up front. It stands the best chance of selecting the right audience and preparing them to respond. Plus, if they read nothing else, they have at least seen the best selling point you have to offer. If you have trouble writing this kind of headline, it's a sure sign you need to think a bit more about your product or service.
- Now! Moonlight Your Way to a Million Dollars.
- Create your own cards, posters and banners in minutes! • Get a FREE vase when you buy a dozen roses.

14. Announce exciting news.
People read newspapers and magazines because they love news. It's just basic human nature. We're curious. We not only want to know, we need to know. Casting your headline in a way that suggests news, rather than advertising, can have the same powerful appeal of a feature story in the morning paper. An important note: the product or service doesn't

necessarily have to be newly created to qualify as news. It merely must be news to your reader.

At Last, American Scientists Have Created the Perfect Alternative to a Mined Diamond!
- Introducing the newest idea in cross training. From NordicTrack.
- Now program your DVR by simply speaking to the revolutionary DVR VOICE programmer.

15. Appeal to the "how to" instinct.

The how to headline appeals to the need most of us must improve ourselves or our lives in some way. The secret here is to focus on a need or want and promise to fulfill that need or want. Be careful, though. The how to must highlight the benefit or result, not the process itself. Look at this example:

How to make money working from home with your PC.

Suppose instead it read, "How to start a full-time computer business in your home." This misses the point, doesn't it? It sounds like a lot of work. It says nothing about the real motivator, which is using a computer you already own to make money easily. To write a how to headline, begin with the words "How to" or "How" then immediately fill in the benefit.

- How to stop smoking in 30 days ... or your money back.
- How You Can Profit From the 3 Greatest Service Businesses of the Decade! • How to do Central America on $17 a day.

16. Pose a provocative question.

Asking a question directly involves your reader. However, your question cannot be random or clever. It must relate directly and clearly to the major benefit of the product. It must also prod the reader to answer "yes" or at least "I'm not sure, but I want to know more." • Do You Make These Six Common Mistakes on Your Taxes?

- Gotten a speeding ticket lately? Read this.
- How do I know which mutual funds may be right for me?

17. Bark a command.

Sales copy often falls flat because it fails to tell the reader what to do. This headline type allows you to be direct, provide a benefit, and take a commanding posture simultaneously. It's not conversational, it's dictatorial — but in

an acceptable way that readers have come to expect in clear writing.

- Become a famous blogger in 60 days.
- Call anyone, anywhere, without a phone line for FREE!
- Stop wasting money on Web design. Use InstaSite to create your own Web site in minutes.

18. Offer useful information.

Let me clue you in on a little secret. Most people don't want information. I know you've always been taught otherwise, but it's true. People are drowning in facts. What people really want is a sense of order and predictability in their lives. We want to feel a sense of power over our world. Therefore, we seek out the secrets, tips, hints, laws, rules, and systems that promise to help us gain control and make sense of things. Notice how these headlines promise information that does just this.

- THE 20 MOST IMPORTANT STEPS YOU CAN TAKE TO LIVE LONGER.
- FREE. The best kept secrets in America.
- Free brochure shows you how to end your money worries for good.

19. Relay an honest, enthusiastic testimonial.

A testimonial headline can do two things for you. First, it presents your reader with a third-party endorsement of your product or service. Second, it capitalizes on the fact that people like to know what other people say.

- "Quite simply, the finest design software ever released."
- "This diet program worked for me. It can work for you, too!"
- "It's the first book on personal finance that really made sense to me."
- A variation of this strategy is to write a headline in the first person and put quotation marks around it. This "virtual testimonial" gives you a more interesting headline and improves readership.

20. Authenticate your proposition with a little something extra.

People distrust sales copy. And for good reason. A lot of it proves inaccurate or downright dishonest. To cut through this distrust, you can add a little something extra to your headline that seems out of place, yet rings true. Look at the following headlines and notice how the words "Ohio man," "Obsolete," and "Frustrated bartender" stand out. Their specificity or quirkiness adds a truthful aura that traditional copy could never achieve.

- Ohio man has 21-year tested formula to create multimillion dollar business from scratch, without bank loans, venture capitalists or selling stock.
- Small Company's New Golf Ball Flies Too Far; Could Obsolete Many Golf Courses.

- Frustrated bartender develops incredible device to clean and disinfect your entire home...

There are many, many other ways to write a headline. Whatever strategy you choose, don't decide too quickly. Take time to brainstorm. Write dozens or even hundreds of headlines. You never know exactly what you want to say before you say it, so giving yourself plenty of choices is the surest way to arrive at the best, most powerful headline.
So here are 7 more sure-fire headline templates that will work when you're aiming to score more readers:

21. Give Me [brief time period] and I'll Give You [blank].
This headline promises a strong benefit to the reader, like all good headlines do. But this one is especially effective because it promises to deliver in a very brief time.
- Give Me Five Days – And I'll Give You the Secret of Learning any Subject! • Give Me Three Minutes a Day – and I'll Give You a Better Complexion.

22. If You Don't [blank] Now, You'll Hate Yourself Later.

23.
We love to belong, but feeling excluded is a real bummer. Whether it be a financial opportunity or the social event of the year, we simply hate it when we get left out.
- If You're Out of the Market Now, You'll Hate Yourself Later.
- If You're Not at SXSW 2007, You'll Hate Yourself Later.
- If You Don't Edit Your .htaccess Now, Google Will Hate You Later.

24. The Lazy [blank's] Way to [blank].
This headline has always worked well with time pressured people, and that's certainly true for most people today. No one likes to think of themselves as lazy, but everyone likes to save time and effort.
- The Lazy Man's Way to Riches.
- The Lazy Dad's Way to Quickly Getting Dinner on the Table. • The Lazy Blogger's Way to Write Great Post Titles.

25. Do You Recognize the [number] Early Warning Signs of [blank]?
OK, technically this is still a list, but it's wrapped up in a much more compelling structure than your typical "Top 10" article. People want to avoid problems, and this headline promises the critical tips before it's too late.
- Do You Recognize the 7 Early Warning Signs of High Blood Pressure?
- Do You Recognize the 7 Early Warning Signs of an Employee Meltdown? • Do You Recognize the 7 Early Warning Signs of Digg Addiction?

26. See How Easily You Can [desirable result].

We love quick and easy when it comes to learning something new or gaining some advantage.

- See How Easily You Can Learn to Dance This New Way.
- See How Easily You Can Own a Lamborghini Miura.
- See How Easily You Can Increase Traffic with Social Media.

27. You Don't Have to Be [something challenging] to be [desired result].

People almost always have preconceived notions about things, and this can be a barrier to acting. Remove the barrier that stands between them and the desired result with your headline, and people will flock to read what you must say.

- You Don't Have to Be Rich to Retire on a Guaranteed Income for Life.
- You Don't Have to Be a Geek to Make Money Online.
- You Don't Have to Be an A-Lister to Be a Kick-Ass Blogger.

28. Do You Make These Mistakes?

29.
This is always a powerful attention grabber, since no one likes to make mistakes. If you've targeted your content well for your intended audience, helping people avoid common mistakes is a sure-fire winner with this type of headline.
- Do You Make These Mistakes in English?
- Do You Make These Ajax Coding Mistakes?

Chapter 2. Setting Up Your WordPress Blog the Right Way

Now we come to the first tutorial of the course. This WordPress tutorial will guide you easily through the process of creating your WordPress blog. Setting up your blog is one of the easiest and fun steps you will take.

Just click the link below and follow the step-by-step instructions to set up your blog:

www.wordpress.com

Now that you have set up your WordPress blog, we are going to cover some vital details.

Are you ready to get serious about your art blog? Do you want your art blog to be successful and have lots of readers and subscribers?

Then you need to focus on two key elements.

What are they?

The **first key element** that your art blog must have is being **self-hosted**. The **second key element** is having a **premium theme**.

Without these two critical and important key elements, no one is going to take your art blog very seriously.

If you continue to operate your blog with the free hosting from WordPress, then you will always look like an amateur to your visitors and readers. The same thinking holds with your theme. If you continue to use a free theme, you will never look like a true professional to your readers.

Let's look at both key elements in detail.

1) Becoming a Self-Hosted Art Blog

Being self-hosted is critical to the success of your art blog. Why? There are several reasons. But one of the most important reasons is that **it makes you look like a true blogging professional** to your readers and subscribers.

If you have free hosting from WordPress.com, you look like an amateur. **And if you look like an amateur, no one is going to take you very seriously.**

Another important reason you need to be self-hosted is so you can monetize your art blog. If you have free hosting under the WordPress.com domain, you will not be able to sell any of your art or art information products. This is one of the restrictive policies of WordPress.com. But once you become self-hosted, you will no longer have to abide by these rules. You become master of your own universe, able to sell anything on your art blog.

And lastly, another important reason for being self-hosted is that you will rank higher in Google search results. Once you get your own domain name and become self-hosted, the search engines will index and rank your site much higher. This one reason alone is worth the cost of being self-hosted.

I recommended that you use either Bluehost or Hostgator for your art blog hosting. These are solid choices. You will be very happy choosing either of these hosts.

2) Getting a Premium Theme for Your Art Blog

There are several reasons for getting a **Premium Theme** for your art blog. Like being self-hosted, **having a premium theme makes you look more professional**. You will certainly be taken more seriously by your readers and visitors if your art blog looks stellar.

And a Premium Theme can help you do just that.

Another reason you need a Premium Theme is that it will give you more versatility and utility. In simpler words, it will help you do a whole lot more with your site. It will have more

bells and whistles and will help you do lots more neat stuff with your art blog as your business grows over time. For example, you can add a slide show of your most recent art work with a premium theme. Free themes don't give you this option.

I use Prose Theme for this my blog. It has the Genesis Framework and helps my blog rank higher in search engine results.

How Do You Get a Domain Name?

How do you get a domain name?

Two practical tips for choosing your business's web address.

People commonly refer to "buying" domain names, but this isn't quite accurate. What we're really doing is leasing them for a period (1 to 10 years). The company that leases the name to you is called a Domain Name Registrar, and the process is called registering.

There are many registrars out there, with different prices and features. They all have access to the same central database of domain names, so there's no difference in selection or availability of names.

Practical domain name tip #1: .com is still king

"Dot-com" was the first domain name suffix available for commercial use, and it remains the gold standard.

If someone types your domain name in and doesn't remember the suffix, they will assume it's .com. Also, if they type a partial URL and leave off the suffix, today's web browsers will

automatically add .com to the end (try it: Open your browser and type in the single word "Amazon." Where do you end up?). Both "default" behaviors will benefit you—but only if you have a .com address.

If you cannot find your business name in either .com, .net or .org, you may want to consider changing your business name.

There are a couple of suffixes that are available for specific industries or professions. For example, .pro domains may only be registered by doctors, lawyers, and CPAs; .travel is reserved for "travel related entities," and .coop is for co-ops. Here's Wikipedia's complete list of suffixes and the restrictions and requirements for registering them.

In some cases, even an "open" (anyone is eligible to register) suffix like .name, .info or .mobi might be perfect for your individual situation.

But in general, you should try to get a .com address, and supplement it with additional suffixes for good measure.

Practical domain name tip #2: Domains are cheap! Go ahead and buy a bunch

The most I've ever paid for a .com domain for one year is $10. The point is, it's hard to over-invest in domain names because they are very cheap. For something that represents your business to the entire online world, 10 bucks a year is a fantastic bargain.

So, don't limit yourself to a single must-be-perfect domain name. Buy 10 or 20 or 50 and use domain forwarding to point them all at the same website (or use specific domains for specific products or campaigns).

After you purchase multiple suffix versions of your domain like .net, .biz and .org, you can start to look at spelling (and other) variations. If you spell your name unusually, then snap up the phonetic spelling or a couple of variants (like Andersen and Anderson, for example).

Consider registering versions of the domains you already have, with hyphens between the words. Other options to consider include plurals, verb forms, and locations.

For example, say your business is all about being a positive parent. You could register: PositiveParent.com
PositiveParents.com
PositiveParenting.com
PositiveParentGroup.com
PositiveParentsInc.com
PositiveParentsInCalifornia.com
…and that's just for starters. Brainstorm a list — it can be fun!

The #1 WordPress web hosting mistake Don't be fooled by "free hosting" offers!

You can pay thousands of dollars per month to have your own in-house hosting solution. You can pay hundreds of dollars per month for "business hosting." But most small businesses simply aren't in the market for expensive hosting — at least not when they're first starting out.

What about WordPress.com and Blogger?

First, let's explain the difference between **WordPress.com** and **WordPress.org.** They are related, but they are different, and the differences are *important*.

WordPress is free, open-source software, which means anyone can use it, distribute it, and modify the source code. WordPress.org is the official home of this software and information about it.

- WordPress.com is owned by some of the same people who developed WordPress, and it's a hosted version of WordPress. There's no self- before "hosted" because the hosting is all on servers controlled by WordPress.com.
- Instead of renting server space where you install the WordPress software, you sign up for a free account on WordPress.com, and you get a hosted version of the WordPress software that is installed and maintained for you.

Sound good? A free WordPress.com account is a great deal for non-commercial websites. **But for businesses, the trade-offs are too great. If you are running a business online, you want full control over everything about your website, and even the paid add-on features of WordPress.com don't give you that control.**

Blogger.com is another popular free service, and the same reasoning applies. If you're running a club or a hobby blog, and you are happy to trade full control for hosting and maintenance, Blogger.com is a wonderful service.

But you're in business, and your website needs to be owned and controlled by you. Self-hosted WordPress websites, using the software you can download at WordPress.org, offer maximum versatility and flexibility.

I recommend you create a self-hosted WordPress site with the software you can download at WordPress.org. Having full control over your

website is worth paying for. And fortunately, you can have that control, plus good customer service and support, for a surprisingly low price.

The pocketbook friendly solution: Budget hosting

Budget hosts charge budget prices — less than $10 per month. You're paying such a low price because you're sharing server space with other budget hosting customers. Therefore, budget hosting is also called shared hosting.

Even though the server is shared, no one can access your hosting control panel but you — and you can't see who else is on your server. In sharing server space, you're taking the risk that someone else on the same server will experience a traffic spike and bring down the whole server — and subjecting your server mates to the same risk if your latest blog post goes viral.

Good hosts will at least attempt to balance the server load to prevent these events, and they also respond quickly when it does happen. They also offer tools and upgrades to help you as your site traffic grows.

No host, no matter how much you're paying, is error- or outage free. We feel that budget hosting is "good enough" for most small businesses.

So how do you choose a host, anyway?

Now that we've defined hosting, and explained why self-hosting is ideal for businesses, you're probably wondering how to choose a web host. After all, there are thousands of hosts out there, and every single one of them has both raving fans and former customers with horror stories to tell.

I've come up with a checklist of nine tests your WordPress web host must have, and I'll share it with you in the next lesson.

The Definitive WordPress Host Checklist

9 Must-have features that will keep your website flexible, online, and always available

If a web host you're considering does not meet these criteria, don't even think about signing up for a hosting account.

Any web host you're considering for a WordPress site needs to:

1. **Allow hosting of multiple domains for no extra charge.** Note that we're talking about hosting, not registration. Even if you're only planning on running one site, having the ability

 to build a test site (for instance, at a subdomain like testsite.yourdomain.com) or promotion specific sites is important.

2. **Offer unlimited storage space and bandwidth**. This is a loaded topic, because really, we all know that on a shared server, these resources can't literally be unlimited. The point is that you do not want to be worrying about whether your latest blog post will push you over your bandwidth limit.
3. **Provide an effortless way to communicate with them** — to ask questions, submit a trouble ticket, etc.
4. **Provide an effortless way to check the host's system status**, so you can quickly find out if your server is experiencing an outage and what's being done about it, without having to submit a trouble ticket and wait for a response.
5. **Mention WordPress prominently in its sales materials**. Look for phrases like "one click WordPress install" or "WordPress support" or "easy WordPress install."

6. **Offer a free trial period or a (limited time) money-back guarantee.** You should be able to evaluate the service over at least a few weeks to figure out if you're comfortable there.

The next three requirements are technical, so don't freak out! Just look for these words and phrases somewhere in the web host's sales material. If need be, just copy this list, paste it into an email to the web host, and ask them to confirm that they meet these requirements. Good hosts will be happy to do so.

1. **Linux web servers** (not Windows) with the Apache mod_rewrite module enabled.
2. **PHP version 5.2.4 or greater** (that's the programming language that runs WordPress — you don't have to know that language to use WordPress effectively).
3. **MySQL version 5.0 or greater** (this is the database that powers WordPress)

And a bonus backup requirement: To safely and effectively back up your site, your web host needs to allow access to the Linux command line Zip command via PHP's exec() function.

My Favorite Web Hosts

Now that you're armed with some criteria, who meets it? Many hosts do, but even in this elite group, some hosts are better than others. My research includes installing, maintaining and troubleshooting WordPress on a wide variety of hosts, and I'm confident in my top two contenders.

Here are my top two recommended budget web hosts:
If you want to be able to reach your hosting provider 24/7 on the phone, consider my top choice:

My top choice for budget hosting is Hostgator

It should go without saying that this host meets my nine criteria, but I'm saying it anyway. **This host meets my criteria and then some. If fact, this is the host that I use for my WordPress blog.**

I picked **Hostgator** because they transferred my WordPress.com blog to their servers completely free of charge. It was very simple and easy to go from WordPress.com to my own self-hosted site because **they did the transfer, they did all the work.**

They took care of all the details and it only took a couple of hours for them to make the transfer. It was super easy and **required no technical knowledge or effort on my part.** What could be simpler and easier than that?

What I like about Hostgator:
- If you're moving a site from WordPress.com, **Hostgator support will transfer your site content for free!**
- **24/7 phone support,** which you can even use to call before you sign up to ask any questions you may have (I suggest asking them about my nine criteria, of course).
- **Support options** include a company support portal, discussion forums (including a Network Status forum) and a detailed library of video tutorials.
- **Quick install WordPress installation script** makes installing the latest version of WordPress easy.
- Although Hostgator doesn't offer a free trial, their **45-day money-back guarantee** gives you plenty of time to check out the company's support (such as forums that are only available to customers) and features.
- **I recommend the middle hosting tier (the "Baby" plan)** because it includes hosting of unlimited domains.

My second recommended host is Bluehost
This is another host that meets my criteria and then some. Here are the features I like about BlueHost:
- **Bluehost is the number one recommended host by WordPress for the last 10 years. Need I say more!**
- **Good security.** Every WordPress installation uses a unique database prefix, which is something WordPress experts highly recommend.
- **Lots of support/information websites:** An official blog that's equal parts tech, customer service, and humor.
- **A custom control panel and custom one click WordPress install** that are

 user-friendly and written in plain English.

- **Free trial PLUS a ANYTIME money-back guarantee** (that's the longest one I've seen) gives you the freedom to change your mind at any time.

Unfortunately, even some hosts that claim to support WordPress don't make good on that promise. If your chosen host has a free trial or money-back guarantee, make sure you use the trial or guarantee period to review and use the host's support system. Do your questions get answered? In language that you understand? In a decent time, frame? Make sure you choose a web host you're comfortable with. Your website, your readers, and your pocketbook will all benefit.

Chapter 3. Your Goal: Become an Authority Website

Anyone involved in Internet Marketing, whether as an affiliate, small business, sizable corporation, or personal brand, knows that nearly every day there is someone trying to give you more tips or tricks to bringing in additional profits online. There are so many potential routes you could take to achieving success online that it's easy to get lost and start wondering where the smoke and mirrors end and the real path to success begins.

The truth is, all the marketing tactics in the world don't hold a candle to pursuing the one goal that should matter the most for any site: **becoming an authority.**

You see, effective tactics for marketing come and go. The kind of advertisements that may bring in hordes of visitors to a site today may be totally ineffective a year or two down the road. With the way that Google has been on the rampage with furry little black critters like Panda and Penguin, they can go "quickly" – very quickly.

The source of traffic to your site that is #1 today may end up being last year's fad. The Joint Venture partner that brought you so many visitors might go out of business or prove to be a one hit wonder. The only thing that really matters, the only thing you can unequivocally say is going to be worth investing in now because its value will not diminish over time, is **building an authority website with a diverse traffic model that doesn't rely on a single "tactic de jour."**

That's a bold statement, and we as Internet Marketers hear those all the time, but I want to go further than that today. I want to show you precisely why **authority websites are what**

matter online today and will continue to matter in the future. Once you understand where the value is, you will see that this is indeed the very foundation of your business' enduring success online. I'll also give you some quick and simple tips to help establish and increase your authority, so keep reading.

Trust is the Core Benefit of Website Authority

So, you want your website or even your brand to become a gold standard? That's a great goal, but before that can become a reality, **your site needs to become an authority. The key to developing authority is developing trust. We tend to trust those who are consistent because they appear stable and reliable to us.**

This means that you need to be producing high quality content on a consistent basis, reaffirming to your audience that you are the source of the best information on your given niche.

The best route for this, of course, is a **WordPress blog**. If you can do this without slowing down to chase other marketing "butterflies" that come along from time to time, **you will have a site that is a repository of killer content your audience can't find elsewhere.**

Focus on bringing your readers eye-opening content that educates them, or deliver entertaining content that makes them feel good. Figure out what they want and deliver it. Then keep delivering it on a regular schedule they can depend on. This is the basic recipe for gaining trust, and once your site has gained the trust of enough people, and they begin to talk about the content your site contains, your authority becomes obvious not just to human readers, but to the search engines as well.

But why go through all this effort? Isn't it a lot of work?

That's really the "pink elephant" in the room. Everyone has this misconception that building an authority site is "hard" or that it is "a lot of work." But the fact is that that is just a myth. It's far easier to focus on building a reputable authority site that promotes 100's of products than it is to create, maintain and promote 100 sites each promoting one product.

Most people will go down a mini-site model path for six months to a year before realizing that the return on investment (especially time) is just not there or the consistency of income is too volatile. But how much further along your career path will you be if you stop chasing the "pot of gold" at the end of the mini-site model today and instead focus on quality and authority?

Now all that content that we've talked about? All the trust and rapport building with your readers? Why bother, you ask? **Simple – it all translates into sales**. In fact, it is the key to

highly effective marketing. **You see, the "holy grail" of marketing is to be so effective as to not even require selling.**

If your marketing is top notch, selling is like taking candy from a baby. But if you take your marketing lessons from the used car salesman on the corner lot and "sell, sell, sell" – you'll probably sell your way right out of business.

Effective content marketing creates a quality authority site that oozes trust, rapport and loyal readers. You can then very subtly drop links and reviews into your content as well as provide "resources" and "recommendations" — all with a very "soft sell" — and watch your conversion rates triple.

We all love to buy – we're all consumers at heart. But the funny thing is that NONE OF US likes to be sold to! Think about that for a bit, and think about how you can use your content marketing strategies to inform, educate and build authority with your users – the sales will come naturally as a byproduct.

Conserve Your Energy & Increase Marketing Potency

In our business, I regularly watch people struggle and even fail. Often, if they listen to my advice and allow me to help them, we turn things around. Other times, unfortunately, they outright tank.

The biggest reason for online ventures failing that I see repeated is that people simply overextend their resources.

They follow the false assumption that more information and more marketing is what they need, so they continue to chase shiny object after shiny object. They work like crazy to expand the reach of their site by any means necessary, but often they do not improve its content. They want to get as many SEO links as they can, for example, but what are they linking to? A lot of the time, the site they have spent so much time and energy promoting is simply not very noteworthy and that makes all that time, money and effort they put into the site a waste.

When you choose to focus instead on making your site an authority, you can dispense with so many different marketing methods. Yes, diversity matters, but your core business is in your site and the content it puts out, not in discovering temporary ways to bring in floods of traffic who bounce right off your landing page or who spend under a minute looking at your site's content, never to return.

You want readers to arrive at your site and feel as if they've discovered something special. You want them to buy something or bookmark the page and maybe even tell a friend or two about what a great site they found. Save your energy and **focus on making brilliant content,** even if that means you don't produce it that often or that you spend more having a

professional create the best possible content your company can afford.

Your Content Becomes Prone to Viral Distribution

When clients tune into our message and begin to focus on getting the kind of content that their visitors trust and gain real value from, incredible things have been known to happen. **The fact is, great articles get read repeatedly, the same way great videos get watched repeatedly. Remember that when you begin to focus on website authority, your primary competition is yourself.**

Everyone knows the power of great content. It's the song you set to repeat on your MP3 player. It's that book you've read several times, or that movie you've seen more times than you like to admit. Follow your instincts and don't settle for content that you know isn't the best it could be. Make it invaluable to your audience and they will spread it for you. **Your readers will become your marketing and sales force – now that's powerful.**

Keep in mind that people will pass on things that are excellent. Why? Because they want the credit for having 'discovered' it and when they share it, they get the social approval they're

looking for. The best content goes viral without you needing to spend a fortune on marketing, especially if you can convince someone else with authority to publicly mention the content your site contains.

Customer Retention Rates Will Soar

The bread and butter of any business is repeat customers. Developing an authority site is all about building a regular audience that comes back for more. This is how you start to carve out a niche that only your business can inhabit. It's how your brand becomes a gold standard online because those regular customers buy enough to let you know how much you can afford to spend making your site and its products even better.

This is what you want to strive for, because the larger your audience is, the more respectable you look to those who are not yet in your audience. Sounds a lot like a large, regular audience denotes authority, then, doesn't it? That's exactly right, and this will have been your goal the entire time.

The Authority Model is a Universal Solution

The best thing is that this model applies to every form of monetization that exists. Whether you're building an art blog, an info product review site, an Amazon review site, a professional services or consulting site – the AUTHORITY MODEL works for all of them.

Imagine the stress that will melt away once you know the approximate size of your customer base and know that you understand how to give them what they want. This is when being in business becomes really rewarding, and it's well worth the time and effort it takes to achieve this level of success. The fact is, when you concentrate your efforts into this authority site, rather than scattering it across

100 trivial sites, your effort is reduced and your results are magnified.

Some Quick Tips for Building More Authority

1. Get a YouTube channel. Create a weekly video to publish in that channel. Make sure to embed that video on your site as well. It's no surprise that Google loves YouTube (they do own it after all) and sites that use video on their site gain authority much quicker than those that don't. Also, your channel becomes an authority itself and gains PageRank quickly so those videos embedded into your site boost up the authority of your site as well.
2. Get to 100 and beyond. **Get 100 posts published** on your site and make them good posts of excellent quality and unique content of 700 words or more. Many of my posts are over 2500 words of unique quality content. The more content, the more long tail keyword traffic you will attract and the quicker you will build your authority.

3. Consistent and frequent posting. **You need to be posting at least two or three times a week to not only build up your site content and footprint within Google, but also to show that you are relevant.** If you have trouble finding what to post about,

use Google Alerts to help you out.

Some Final Thoughts

To say that establishing your website as an authority is easy or fast would be misleading. Instead, what I want to make sure is 100% clear to you is that establishing an authority website is worth doing and worth doing well. In fact, it is not any harder than spinning your wheels building mini-site after mini-site that Google hates anyway.

There is no way to feel more secure in business and take real pride from what you do than to be a trusted authority who provides others with value. This is something anyone can do if they commit to following through on the information laid out in this article.

Go ahead, start taking your first steps. You'll experience the difference right away.

Chapter 4. How to Create a Professional and Profitable Newsletter

What is the best way to increase your income on the internet if you are an artist? For my money, the smartest way to start out with internet marketing is with a simple email newsletter. When an email newsletter is joined with a quality art blog, you have an unstoppable marketing force, one that will put you far ahead of your competitors.

There are a lot of options to deliver your content, images and messages online. Blogs, social media, static Web sites and user generated content sites like Squidoo or Ezine articles all provide an opportunity to get the word out about your artwork.

Each of these has its distinct pros and cons. I love blogging, and this course focuses on combining an email newsletter with a blog and social media.

Static Websites are one option, but they're not the first place I'd put my energy.

For my money, the smartest way to start out with internet marketing is with a simple email newsletter coupled with a blog.

Email newsletters are inexpensive—about $20 a month to deliver. They're faster to put together than a paper newsletter, requiring only minimal graphic layout. And the fun part is, you can create a fantastic sequence of communication, then deliver it again and again to each new person who signs up for your list.

Benefits of using email marketing to your clients, collectors, and gallery contacts

- **90% of your sales will come from an email newsletter – Need I say more?**
- Consistent email contact builds trust which leads to more and greater sales
- Auto-responders send out a sequence of regularly timed messages that you have created in advance. They work for you even when you are away or sleeping. Truly, the lazy man's way to riches.
- Consistent emails constantly keep your name in front of your customers and so they think about you next time they are ready to buy.
- You can offer a series of new products to your clients that are evenly spaced throughout

 your email campaigns. More products offered means more sales

The main reason customers do not buy is that they don't know you and they don't trust you yet.

A consistently delivered email newsletter solves both problems.

Here's your simple formula for creating more sales with an email newsletter:

> **Consistently Delivered Messages = Trust = Sales**

There are a lot of steps to putting an email newsletter together. None of them is rocket science, but put them all together and it can be a little intimidating.

I've seen a lot of folks get bogged down just trying to choose a provider. I completely understand—you don't want to make a mistake or burn a lot of time & energy with the wrong service.

Fortunately, there's an extremely easy answer to this question. **There really is one provider—and no, I don't work for them!—who stands head and shoulders above the rest.**

This article will give you the complete scoop on what you need to look for and why these guys are the gold standard.

Do You Need an Email Newsletter Provider?

A lot of folks think they can "do it themselves" by either sending customer email newsletters through a program like Outlook or (if you're a little more tech-y) writing your own PHP or other program.

"Doing it Yourself" is a BIG MISTAKE here

First, trying to send out bulk email to more than 10 or 20 people gets complicated in a hurry. You lose track of who's already gotten what. You must create folders and subfolders.

Your local email service starts to get cranky with you (sometimes very cranky) because you're sending too much stuff. It's just messy.

But that's not the reason not to do it.

You need a special email newsletter provider because if you don't, one of these days you will be marked as a SPAMMER.

It's a little-known fact that most of the email that gets marked as spam is completely legit. People click that "spam" button if they forget that they signed up to hear from you, or if they're just not as interested as they used to be.

A lot of the time, they even click the SPAM button completely by accident. Before you know it, the "big guys" have sent your name around as a "bad character," and NONE of your email gets delivered . . . **to ANYONE.**

Not your personal mail wishing your grandma a happy birthday, not the business mail you use to confirm delivery of your product, NOTHING.

You really don't want that to happen.

Use a reliable email newsletter service and they manage all those relationships for you, so your mail will get delivered consistently. They send from a completely different computer, so your personal email can never be accidentally marked as a spammer.

The good ones also give you a heads up if you've written something that will raise the "spam" flag on the automatic filters (you'll be amazed at some of what gets flagged).

They deal with all the hassles for you, and they keep things simple and organized. You just spend a few minutes typing your content in and they take it from there.

A dedicated service to send your email newsletters is a critical business expense just like having a phone line is—and it's just as dumb to try to go without it!

A PIECE OF "EXPERT" ADVICE YOU MUST IGNORE

Lately, some of the "experts" have been telling folks that deliverability (that's the jargon for whether your email gets to your readers without landing in a "junk" folder) is only about content. They claim that the spam filters just check for certain words, and if you keep your nose clean your stuff will sail through.

These are people who have little or no experience testing different email providers.

OK, it's partly true. Yes, you must have good, valuable content. And you can't be a spammer. It helps a lot of you send something your customers want to get.

But that's not the only piece of the puzzle.

As a matter of fact, it matters a lot who's sending your email newsletter for you. Some of the bigger names (including some you see advertising in the business journals and magazines) don't spend the time they should creating solid relationships with the email providers.

They're not on the phone with Gmail, Yahoo, Earthlink, Comcast and all those other guys, making sure that those providers are delivering your email.

And if you publish a newsletter with one of these not-so-great services, even if you have the best content in the world on a totally harmless subject, you can see anything from 10-25% OR WORSE caught in spam filters.

Let's be clear. When your newsletter gets stuck in a spam filter, your customers can't read it. Which means they don't forward it to their friends or come in to check out your great new promotion.

Which means 10-25% OR WORSE of your money and time are WASTED.
I don't want to get into any fights or make anyone's enemies list, so I'm not going to name the providers I've seen firsthand do a lousy job of managing the spam filters.

In fact, I'm just going to give you one name—the "gold standard" for sending mass email. My 8% rejection rate shrank down to under 1%. My clickthroughs (that's folks who click on a link in your email—important to keep track of, because that means you've got interested readers who are motivated to act) improved by about five times. That's all I needed to see—I'm a believer.

THE BEST EMAIL NEWSLETTER PROVIDER I'VE FOUND ANYWHERE

OK, enough with the suspense already. The best email newsletter provider for small businesses (or even big ones, in my opinion) is a company called Aweber.

I haven't seen any other provider come close to getting your email past the spam filters.

If you've been hanging around the Internet Marketing dudes, you know this name already—they're simply the best.

Not only does their email get delivered much more consistently, but it's a very EASY program to use.

IF IT'S THE BEST, DOES THAT MEAN IT'S EXPENSIVE?

Aweber costs a little under $20 a month for the basic package, which gives you up to 250 subscribers. Then it jumps to $29 a month for up to 2,500 subscribers, with modest increases as you get more people on your lists.

Other than some of the great free services provided by Google, I can't think of a better, smarter bargain for any business owner or organization. Anyone.

Remember, it's not just cheap with GREAT features, but the Aweber program is designed for folks who don't have a PhD in computer programming. Setting up Aweber is about as easy as

it gets—if you managed to figure out how your email program works, you're overqualified to use Aweber.

(No, I don't work for them and I don't own their stock. Maybe I should find out if they even offer stock, so I can buy some. It's just really, truly that good. No baloney.)

A MISTAKE EVEN EXPERTS MAKE

Occasionally, I see a business owner using the email provider that comes with their shopping cart program, or their web domain host, or whatever.

Even people who ought to know better do this. I guess they don't like the idea of paying **for a** new program when they can use something they already bought.

Don't do it. Your customers can "white list" you (that means they add you to their email as a safe sender) until they're blue in the face, some of your messages are still going to get jammed up in their spam filters.

These "add-on" emailers just don't put as much time and energy into making sure as much email as humanly possible gets in front of your customers, instead of getting stuck in a spam or "junk" box somewhere.

Use a good, dedicated service with an EXCELLENT reputation for deliverability, whether it's Aweber or another service.

How to Sell Art Online: The Secret Sauce

Why do some internet artists make money so easily — while you try everything possible and get barely enough customers, sales and profits? What if there was a way you could convert

15%, 25%—even 50% or more of your online customers, how much more money would you earn as a result?

If you could read just one article about how to turn your efforts into an unstoppable selling machine, this is it. I dare you to read this entire article and not change the way you sell art on the web.

A lot of people who write about business will tell you that there is no one magic bullet that will lead you to success. They will tell you there is no secret sauce.
But I'm here to dispel that myth now. There really is a secret sauce. You know what it is?

The Secret Sauce

The Secret Sauce is building relationships with people. It's starting and growing relationships online. Pretty simple, huh?

Nothing will lead to success in business (Internet or brick and mortar) faster than starting and growing relationships. It doesn't matter what you sell. Even if you sell harmonicas to nomadic tribes in South Africa, starting and growing relationships will make you the hit of the century in that market.

But a lot of Internet artists get this all wrong. I see it all the time. They put up a static website or a storefront on eBay or Etsy (or some other group artist website), and then they wonder why no one ever buys anything.

Let me ask you one important question: Does a static website or a storefront on eBay or Etsy have the elements to start and grow relationships? Of course not.

Those things may be cool and fun to play with, but they're essentially just like a big billboard in Cyberspace. People may drive by and see it, but they never come back that way to see it again. And they forget about it very, very quickly.

Get the Secret Sauce into Your Online Art Business

So, what is the solution? Simple. You need to have a way to effectively start and grow relationships online.

What are some ways to start and grow relationships? Social Media like Facebook and Twitter will do it, of course. And Social Media should certainly be part of your online art business strategy. But it's not at the top of my list. It's not the very best way.

What is the best way, then?

For my money, the best way to start and grow relationships online is to use an **email newsletter.** And, of course, I'm talking about permission based email marketing only here.

Never be a dirty rotten spammer.

Think about it for a minute. What better way to start and grow a relationship with someone than to show up in their personal email inbox every seven to ten days? Are you beginning to see how powerful this is? They can write you back if they have a question or comment. And presto, now you have a conversation going. And conversation is the beginner and sustainer of relationship. Wow! Wow! That's powerful times infinity. That really is a secret sauce, a magic bullet.

The Two Ingredients of the Secret Sauce

The Secret Sauce has two ingredients. Ingredient Number One is: Get the relationship started. And Ingredient Number Two is: Grow the relationship. To get the relationship started, you simply get the person to sign up for your email newsletter. Then you must grow the relationship. How do you do these two things?

There's lot of ways to get the relationship started, to get people to sign up for your email newsletter. One way is to put a page on your site that advertises and promotes your newsletter. Offer something free (like an eBook or report or coupon) in exchange for their email address. Like I said, there are lots of ways to get the relationship going with someone. But this is how many people do it very successfully.

Once you have the person's name on your list, then you must continue to grow the relationship. You must send her emails on a regular basis. If you don't write your new friend often, she will soon forget who you are. Don't abandon her. Don't neglect your new friend. Keep in touch with her often and let them know what you're up to. She will reward you by buying your products or services.

Very Important Note: You must use **BOTH** ingredients to get the magic of the secret sauce. You can't just use ingredient Number One and expect magical things. You can't just start the relationship and then forget about it or only write once or twice a year. You must actively use ingredient Number Two. You must write two to three times a month to keep the relationship growing. Then and **ONLY THEN** will you start seeing the magic of the Secret Sauce take effect.

A few last words….

There's no way around it. The only way to have an abundant life as an artist on the Internet is by starting and growing relationships. It really is the Secret Sauce to succeeding online.

I'm now going to ask you the most important question in this article: What are you waiting for?

The sooner you get going with this, the better. When you work hard on starting and growing relationships, your online art business will always prosper.

Your Email Newsletter: The Magic Rosebush

There's a saying in online marketing, "The money is in the list." I am a big believer in this saying.

The money **certainly** is in the list, the email newsletter list, that is.

I want you to think of your email newsletter and your email list as a rosebush that produces beautiful, prize-winning roses. But this is not just any rosebush. **It's a magic rosebush.**

Why is it magic?

Because this rosebush **grows money instead of roses.** Have I got your attention? Let's look at this analogy more closely.

If you've ever tried to grow roses (especially prize-winning roses), you know they need a lot of care. You must feed and water them on a regular basis. You must prune the branches at certain times of the year to get the biggest and best rose blooms possible. And you must spray to prevent pests and disease.

In short, it's a lot of work to grow prize-winning roses. **If you don't do the work necessary to maintain the roses, they will very likely die.**

The same is true for your email newsletter and its accompanying list. **If you don't do the necessary work for your email newsletter, it will also die.**

So, let's look at your magic rosebush to see how to keep it thriving and growing those prize-winning roses.

Your Email Newsletter: The Magic Rosebush

I want you to think of each part of your email newsletter as a part of a rosebush. In a rosebush you have the new, leafy green growth. You have the buds that turn into roses. You have the roots. And you also have the dead and dying branches, which need pruning on a regular basis.

The New, Green Leafy Growth

The new and green leafy growth of the rosebush is like your new subscribers to your email list. If you do a "excellent job" on this part of your list, it will keep growing and growing. You will have a constant and steady stream of new subscribers.

How do you take "diligent care" of this part of your list?

I will explain in the Marketing Module and future lessons in this course how to devise strategies that will get you lots of subscribers to your email newsletter. But for now, here is a summary of some ideas to get you on the fast track to success with getting subscribers.

First, you want to make sure you have a good landing page on your blog that is just about your email newsletter. When people "land" on this "landing page" they will read all about the benefits of subscribing to your email newsletter.

Second, you will need a sign-in form or opt-in form that will be displayed very prominently on your blog. It is the most eye-catching feature when you first land on my blog. It is the first thing you see when you land on the page and is hard to miss. And that's the whole point, it's hard to miss. And it is on every page. You create your sign in form using your email list provider and then load the html code into your blog.

It's actually a very simple and easy thing to do. Just follow the instructions from your email provider to create the widgets and load them into your blog

Third, you want to write blog posts that feature your email newsletter. I have many of these in my blog post archive.

I use a sign in form at the bottom of the post as well as some colorful graphics to drive the readers to subscribe. This is a great strategy and you should have many, many of these kinds of posts in your archives. Again, I will go into detail about these strategies in the Marketing Module later in this course.

Fourth, you want to create "gateway" subscription blog posts.
A gateway subscription blog post is an excellent way to get more subscribers to your newsletter.

Take **one of your most popular posts** and block it with a subscription gateway. In other words, people must subscribe to the newsletter to be able to read the entire post

Do you see how and why this is an important strategy? People must subscribe to my newsletter to finish reading the post. This is a very effective strategy for getting new subscribers.

The key for this to work effectively is that the blog post must be one that your readers are really wanting to read. As you write more and more blog posts, you will begin to discover which of

your posts fall into this category. It will be a blog post that will be shared a lot and commented on a lot. Also, it could be a blog post that ranks high in Google search and gets a lot of daily traffic because of the high-ranking. That's how you will know which blog posts to use for this strategy.

The Roots of the Magic Rosebush

The roots of the rosebush are like the messages you have written and that are sent in sequence to your readers. The roots of the rosebush are the most important part of the plant. And in comparison, this root system of messages is the core of your newsletter. This sequence of messages is what your subscribers tune in to read each week. They receive these message in their inbox and respond by opening and reading them.

You will need an autoresponder from your email newsletter provider that will send your saved messages automatically each week. You just set it and forget it. The autoresponder does all the work.

I have learned over the years that this sequence of messages does not have to remain static once you have it written. You can tinker with them and make them better over time. You can tweak and adjust here and there until your messages are the best and most interesting they can be.

Also, if you plan on writing a sequence of 55 messages, you don't have to sit down and write them all at once. Start out with just 3 or 4 messages spaced out over the first month. Then write one or two messages a week to stay ahead of the first subscribers who have signed up. This gets you going with your newsletter without a lot of time invested up front.

What are the best time sequences to send out your newsletter? I like prime numbers: 3, 5, 7 and 9 days are good. Once they receive your welcome message, then send out the first message the next day. Then send the next message 3 days later. Then the next message goes 5 days later. The next message is scheduled to arrive 7 days later. And from then on messages are scheduled to arrive in intervals of 9 days. That will give them about 3 newsletter messages from you each month.

The Dead and Dying Branches of the Magic Rosebush

The dead and dying branches of the rosebush is like the people who unsubscribe from your list. Unsubscribes on your list is very normal and natural, just like when you must prune dead wood from your rose branches.

The percentage of unsubscribes you have each month is called the attrition rate. Your attrition rate should be somewhere between 3% to 7% of your subscribers each month. This range of 3% to 7% unsubscribes is acceptable and within normal ranges. So, let's say your attrition rate is 4% and you have 1,000 subscribers on your list. That means you will lose 40 people or have 40 unsubscribes (.04 x 1,000) each month.

Another way to look at this attrition rate of 4% would be to say that you will lose 48% of your list each year (12 months x .04 = .48 or 48%.) So, it is perfectly normal to expect to lose almost half of your list each year.

Red Flag: If you're attrition rate is higher than 7%, this means that you have a real disconnect with your readers. It means something is very wrong. Either the quality of your messages is not good enough or you are not delivering what the readers expected to get. You will have to do some research with your subscribers by asking them what they think of your newsletter and why are they unsubscribing.

The Buds and Rose Blooms of the Magic Rosebush

The buds and rose blooms are like the rewards you reap from all your challenging work with your email list. In this case, it is the money you make from sales of your products and services.

Each subscriber will be worth a certain amount of money to you each month. This amount will vary widely, depending on the products and services you offer, the quality of those products and services and how well you motivate your subscribers to buy from you.

Though the amount may vary, you should expect to make from $0.15 to $1.00 per subscriber each month on your list. For example, if you have 1,000 subscribers on your email list and your average profit per subscriber each month is $0.22, then you will make $220 each month from your list on average.

Do you see how exciting this is? If you want to make more money each month, just get more subscribers. To double your income, just double your subscribers. To triple your income, just triple your subscribers.

Watering, Feeding and Spraying the Roses

Watering, feeding and spraying the roses, is the time you take to put into each element of your newsletter and email list that we described in this blog post. It is the time and care you give to writing and carefully crafting your sequence of messages.

It is the time and care you give to answering each question that someone asks you via email from your list. It is the diligence to stay on top of these questions and issues that your subscribers will have.

A Few Last Words about Your Magic Rosebush

Most email providers will allow you to use templates to create your newsletter. I suggest that you don't use templates for your newsletter. You want your newsletter to look like it comes from a friend or relative who has just written them. You don't want it to look like it comes from a company or a group of people.

A personal look is more powerful than a corporate look.

If you have signed up for one of my email newsletters, think of all the emails you have received from me. They look just like regular emails with no templates or pictures. This personal look gives you a powerful advantage over a big impersonal company.

Also, the HTML code in templates tend to get stuck in spam filters more often. You will get more messages through using just a plain message for your emails.

In conclusion, your email newsletter is one of your most important tools in your online marketing strategy. Take care of this magic rose, and it will always take care of you by giving you loyal readers and buyers of your products.

Become a Happy Habit for Your Readers

Have you ever been too busy to do good follow-up? Ever had health problems, or family emergencies, or just times when you were too busy to keep everything going the way you wanted to?

Has your project ever suffered because you were too busy to take care of new customers? If it hasn't happened to you yet, fasten your seatbelt, because it will. As the bumper sticker says, Stuff happens.

(OK, that's not what the bumper sticker says, but I like to keep this G-rated.)

There is a terrific tool that can take care of new readers for you, starting with the first minute they sign up for your email newsletter. It answers their preliminary questions and resolves their most common objections. It holds their hands and patiently delivers great advice for solving their problems. **And it never takes a sick day, gets tired or bored, or burns out.**

That tool is called an email autoresponder. If you're not taking advantage of it now, you're going to go nuts over how well it can take care of your new readers. Every time.

An autoresponder delivers the authoritative, friendly, trust building messages we've been talking about, in a sequence you can perfect over time, and it takes the same great care of your millionth reader that it did of your first reader.

The reason people don't buy from you is because they don't know you and they don't trust you yet. A consistently delivered email newsletter solves both main problems.

Here's your simple formula for creating more sales with an email newsletter:

> **Consistently Delivered Messages = Trust = Sales**

The part I like best is that your very best content keeps working hard for you. With a blog, most readers may never find your all-time best post. On a Web site, your readers may choose a different path through your content than you would like. **But an autoresponder provides your very best stuff, in the order you want, every time.**

So, what goes into an autoresponder sequence? I'm going to into a lot of detail about the content of your email messages and ideas on what you should say in my next article, so be on the lookout for that.

But the underlying formula is straightforward, but with plenty of room for creativity and experimentation.

You start by figuring out where this new reader starts out when she shows up at your door. You're going to start with "Point A." **Where does your perfect reader start when she first finds you?** What questions does she have? What keeps her from immediately signing up for your product or service? What's worrying her? What are her immediate needs? How about long-term needs?

Now paint another picture, of "Point B." **Where do you want your perfect reader to end up?**
What products will she buy? What knowledge will she have? How will she use that knowledge? What additional services will she sign up for? Remember, this is your ideal scenario. What's your version of a grand slam home run?

The last part of the exercise: **What needs to happen to move that perfect reader from Point A to Point B?** What does she need to learn? What does she need to consider? What concerns need to be put to rest? What does she need to get excited about?

Create an individual autoresponder message for every different point. Start with the most important points, of course. If the complete sequence is 183 messages long, that's ok. The reader will take as long as she needs to take. (And continuing to send her messages doesn't cost you any more than abandoning her does.) Your job is just to build the conveyor belt, whether it's long or short, that will move her there.

You don't have to launch your autoresponder with all 183 messages. Just go with the 5-10 you think are most important, then keep adding to the sequence over time.

What Do You Write About in Your Email Newsletter?

Do you subscribe to many email newsletters yourself?

I subscribe to lots of them. Some I rarely read, or I stick them in a folder for "some time." ("Some time" usually never comes.) Eventually I unsubscribe, realizing that I'm never going to make time for them.

Then there are a few that I *make* time for. If they don't come, I anxiously look through my spam folder to see if they might mistakenly have landed there. When these favored newsletters arrive, I sit down, focus my attention for 5 or 10 minutes, and read what they must say.

What makes the difference? That's what this lesson is all about.

How to Create Rewarding Content Your Subscribers Will Want to Read

Every post or article you create needs to have a little nugget of what I call *cookie content*. Cookie content is a little piece of useful information that benefits that reader.
The best cookies show off your unique area of expertise and are closely related to your art blog topics. You want there to be perfect continuity between your art blog and your email newsletter.

In other words, whatever you write about in your art blog is what you will write about in your email newsletter. Does this make sense?

In fact, many of the sequences in your email newsletter should just be teasers that bring your readers back to read a specific post in your blog. Do you understand how powerful this is for getting repeat traffic back to your blog?

Here are some examples of email newsletter topics. Let's say that you are an abstract oil painter and your art blog is about how to make a home more inviting with art. Then your cookies in your email newsletter (just like in your art blog) could be tips on how to make a home more beautiful, cozy, and inviting with original works of art, tips for coordinating colors in a living room or bedroom, tips for making art the focal point of a beautiful room.

You could also include tips on how to frame and how to choose the right frame for an original work of art.

You might run out of interesting decorating tips quickly, so feel free to expand to all kinds of little tips and tricks for keeping

your customers' valuable original artwork cleaned and properly displayed.

But try not to branch out into something completely irrelevant. You're establishing your authority as "folks who know a lot about making my home more beautiful with art." You probably want to stay away from general household cleaning hints or gardening tips.

In Module 1, you learned about writing eye-catching headlines. So be sure and review the related lessons on writing headlines because this skill is extremely important to the open rate of your emails. The better the headlines of your email newsletter, the more people will open and read them.

Here are some examples of great newsletter ideas crafted with powerful headlines:
- 3 Ways to Brighten Up Your Living Room with Original Oil Paintings
- How to Make a Garden Come Alive with Metal Sculpture
- 6 Ideas to Make Your Child's Room More Fun with Art
- How to Make Your Bedroom Cozier with Photo Portraits

- Bring a Kitchen to Life with Handmade Ceramic Vases

Are you starting to get the picture here? In this example, the blogger is establishing themselves as an expert on enhancing the beauty of a home with art, a kind of "Martha Stewart" of home decorating ideas with the focus on art.

This strategy works for sculptors, photographers, potters and ceramics artists, and of course, any kind of painter.

Every tip should be something your customer can act on right away. Most people don't come to the Internet to find long-term strategies. If you have great long-term tips, think about how to translate them into immediate action. And make sure that most of your cookie content can benefit your customers *today*.

Keeping the Well Filled

You're going to need an awful lot of tips. Which means you need to start collecting ideas *now* and keep them where you can find them again.

Create a file folder. And then brainstorm 50 tips you can write about. Every time a new tip occurs to you, scribble it on any old piece of paper and make sure you get it into that folder.

It's a very good idea to type out a list of ideas for future tips and get it onto the Web in some way (you can always create a Gmail account and email them to yourself). If your house burns to the ground, you'll still have your newsletter tips.

No kidding. They're that important, and you need to keep plenty of "water in the well" so you don't run dry.

Consistency matters when we're training our customers. If their cookie is missing for one piece of content, and then two in a

row, you're training them to put your material aside for another time. Always reward your customers for taking the time to read your content. **Give them a cookie each time.** It works!

How Do You Convince People to Subscribe to Your Email Newsletter?

When you ask every reader to confirm that they want to receive your email newsletter (which you always should), you create both an opportunity and a challenge.

It's an opportunity because you end up with truly high-quality prospects who are much more likely to respond to your offers.

But it's a challenge to get folks to complete that last step. Your customer is a busy person, and spam makes her completely nuts. In the past, she's given her email address to other vendors who sent her irrelevant junk she didn't want. She needs something to tip the scales in your favor, or she's not likely to take the final step of approving that opt-in.

When a customer gives you permission to market to her (which is what's happening when she opts in to your email newsletter), she is giving you a valuable gift. **You need to repay that obligation.**

The solution: create something of value in exchange for that email address. **A valuable thank-you gift tilts the balance back in your favor and puts the relationship in the right psychological space.**

(This is a challenge for email newsletters, because everyone in the world hates spam, but it works just as well to reward any kind of subscription–to a blog, to a paid subscription site, or even to a paper newsletter delivered by good old snail mail.)

Remember the Cookie?

When your customer opts in to your email newsletter, you need to reward her with a major treat.

You'll need to do a little better than a cookie–I call this the ***birthday cake***.

A birthday cake is a gift that you give in exchange for customers joining your email newsletter. That gift needs to be remarkable enough to really capture her attention and imagination. It must be something she really *wants*.

The gift could be a sample of your product or a cash off coupon. If so, this is no time to pinch pennies. Experiment with pricing, but I'd suggest $50 as the right cash value for most situations. It's enough money to get a customer's attention, but not enough to break your bank. (Remember that some customers will forget to ever use the coupon, and many others will use the coupon but buy additional products in the same sale. Your cost per subscriber will always be somewhat lower than the cost of your coupon.)

You could also create a special limited edition of your usual product, available only to those who sign up for your newsletter.

If you go this last route, never make that special edition available to anyone else under any other circumstances. One of the key underlying messages of your newsletter must always be: ***You live by your word and you do what you say you will do***.

Bake Your Birthday Cake Once, Deliver It 10,000 Times

There's another possibility that works extremely well for virtually any business or service imaginable—the free report.

Creating a valuable PDF report, which you then deliver for free in exchange for an email address, takes some time and attention. This is one task that can justify some help from a professional copywriter, but you will do just fine writing it yourself. You do the work once, and reap the benefits forever. For the cost of 4 or 5 coupons, you can deliver your report a thousand times or a million times—there's absolutely zero added cost.

A free report needs to benefit your customer by giving her valuable information that will improve her life. It establishes you as an authority and trusted adviser in your field. And like all free gifts, it puts your customer into a subtle psychological position of indebtedness.

Offer a 10-Part Free Online Course

There's one last offer that works well for getting people to subscribe to your newsletter—the free online class or course.

Creating a 5 or 10-part free eClass, which you then deliver in exchange for an email address is a wonderful way to get interested subscribers opening your newsletter. As with the free report, you do the work once, and reap the benefits forever.

And like the free report, the eClass or online course you offer needs to benefit your customer by giving her valuable information that will improve her life. It establishes you as an authority and trusted adviser in your field. And like all free gifts, it puts your customer into a subtle psychological position of indebtedness.

Make 'Em An Offer in Your Email Newsletter

Once you have your first few basic newsletter messages written, you will need to start experimenting with putting in a few offers. These offers, of course, are going to be for your art and art information products.

It may take some time and tinkering to get your product placement offers and pitches just right. So, it's going to take some trial and error on your part. You're always going to have to do some muddling to find just the right product placement.

The good thing is your basic newsletter messages never change. They stay the same. The basic messages are going to be the framework where you hang your product offers. You just go back into your messages and add and remove the product offers as you see fit.

This is where it starts getting a lot of fun. You will need to use your imagination and try to weave in your product offers. Sometimes you can do this subtly and sometimes you can be very blatant with your product offers. You can add them as ads at the bottom or sides of your newsletter. Or you can just make a reference and a link to the website where the product is offered.

As a rule of thumb, it's best to wait until the seventh or eighth newsletter to begin adding your offers. This gives your readers time to get to know you and establish some trust. So, with this in mind, let's look at the best ways to "make 'em an offer."

Using the Subtle Approach

The subtle approach or "soft sell" is a very effective way to introduce your products to your email newsletter readers.

Let's say your newsletter focuses on how to make the home warmer and inviting with art. And in message #9 you write about how blue is one of the most soothing colors for any room in your home. The headline of the article you've written is "How Blue Can Transform Any Room from Drab to Dreamy."

After you describe the main points of your article, you can then talk about how one of your paintings would work nicely in a blue room. Or you could photoshop one of your paintings into a blue room and show your readers just how great it would look. You could make the photo a link to the "Add to Cart" page on your website and you could then put a caption on the inserted photo that says: "See how great this painting works as a focal point in this blue living room. Click here to Buy this painting now."

Are you starting to get the idea now?

Using the P.S. at the Close of the Newsletter

An effective way to make an offer is at the end of your newsletter with the P.S. at the bottom of the page. You could say something like this: "P.S. I thought you might want to know I have a great painting that would work beautifully as the focal point in the blue living room that I just described.

Click here to look at the painting now."

Studies have shown the P.S. is often one of the most read parts of a newsletter. So, your offer will certainly be seen there.

Using an Example from Your Art Blog

One of the best ways to mention one of your art products is to write it into a blog post

After you have written and set up your blog post as I have described above, then add the post as one of the sequences in your email newsletter. Put the headline in your email headline and copy the first paragraph of the blog post into your email newsletter. Then tell your readers to click the link you provide to finish reading the remainder of the blog post.

You Can Always Use the Direct Approach

The direct approach or "hard sell" gives you another option for adding products to your email newsletter. With the direct approach, you just create an ad at the bottom or side of the newsletter.
Write an ad with links that will take your readers to the landing page where they can purchase the product. Test Ads like this in your newsletter and see what kind of response you get. If your readers find it too blatant, you can always take them off and go for something subtler.

Again, you should always be testing, testing, testing.

Final Thoughts – It's More an Art Than Science

It's more of an art than pure science when it comes to getting the details of your offers structured properly. Like I said above, it's going to take some trial and error on your part to get it right. I can only give you the basic guidelines here.

You can experiment with direct approaches or more subtle approaches and see how your subscribers respond to each. Of course, the final deciding factor in any test is how much money you make and how much you sell from one verses the other.

Chapter 5. The Basics of Online Marketing

What Is The King of the Internet?

Okay, let me tell you.

But it's not what you think so just hear me out (because I'm right about this).

The king of the internet is...

A HIGH CONVERTING SALES FUNNEL!

That's right. If you have a high converting sales funnel, traffic will be coming running to your door! If you have a sales funnel that converts, all you need to do is open it up to affiliates and they will be coming running to put traffic down your funnel.

Think about this for a moment...

With a high converting sales funnel that has either a continuity program or larger back end products that you offer, your lifetime value of a customer will be high enough that you'll be able to go out and buy all the targeted traffic you want.

So, you're probably asking...

What Is a Sales Funnel?

A sales funnel is simply a series of targeted offers.

For instance, imagine you were very interested in marketing and you saw an advertisement online for a marketing eBook. That would be the front end of a sales funnel.

So, the sales funnel might look something like this… **Offer #1** – a free marketing eBook.
Offer #2 – a $19 mp3 marketing audio program **Offer #3** – a $97 series of marketing mp3's.
Offer #4 – a $697 offer for a marketing home study course
Offer #5 – an offer to become a member of a membership website that costs $20 a month.

Here's the kicker…

Now imagine if a person who is interested in marketing went through this sales funnel and purchased an average of $197 in products.

How much would you be willing to pay for a lead?

Right! $197 (assuming you had no costs)

The good news is that the average cost per lead in this market is around $10 or so. Now how much traffic can you buy if your cost per lead is $10, but your average sales per lead is $197?

The answer -> A LOT of traffic!

But it all comes down to one simple thing, having a high converting sales funnel.

Do you have a sales funnel?
EVERY business should have a sales funnel.

Every business should have some type of front end offer and some type of ongoing communication method. If you don't, you should start one right now. I don't care if you're in network marketing, an insurance agent, or you sell shoes.

You should be frequently communicating with the people that know you and making offers to them.

When you make offers to people for products and services that you know will help them, you are helping them to improve their lives.

The Email Newsletter Autoresponder Irony

There is an underestimated power that speaks but makes no sound; is only found underground but is around you all the time; is invisible and inflammable, yet stores tremendous energy.

It has the capacity to endear customers to you, build pent-up demand; to reward, to punish, to liberate.

It can reveal secret channels of communication others are not privy to. It can disclose secrets, provoke fierce loyalty; it can delight and surprise; assure complete satisfaction.

So…

What is this Silent Underground Force?

It is the lowly *autoresponder*.

If only I had a dollar for every "Internet thingy" that's been overhyped far out of proportion to its real substance…. if only *you* had a dollar… you know how the saying goes.

Heaven only knows how many people have tried to pound blood out of stone, getting all those stupid fads and tricks to work.

But autoresponders, pre-timed sequences of email, are UNDER-hyped. And woefully under-used. Oh, and deployed with such little *skill*.

Sure, everybody talks about how you should *have* one.

And I'm sure one out of every three online marketers is signed up for some autoresponder service… with maybe two or three paltry messages loaded in someplace, or maybe just a placeholder.

Hey, for a mere seventeen bucks a month, it's a resource you can afford to ignore. … or is it?

I can count on one hand the number of people I know, who fully and thoroughly squeeze this technology for all it's worth.

And those guys… trust me, they *are* successful. I'll get to that soon.

And while everyone else is selling with a straight sales page, I don't go for the Quick Kill.

Nah… let's do a *slow dance*.

Let's take some time and get to know each other.

Hey, why don't you sign up for my 5-Day email course that will teach you the basics of what I know, and it won't even cost you anything.

The power of a slow dance.

Which is really the power of a real relationship built on *respect and trust*, as opposed to a one night stand.

See, in the swelter of chaos, that little autoresponder buys you *time*. Time to get your message right. Time to get your sales letter right. That's what I did.

It bought me time to do split testing and Taguchi tests. Time to collect more and more testimonials, time to add bonuses to the product, time to create multiple versions of my product at multiple price points. Time to recruit affiliates.

It's that slow dance. Where the guy who holds out the longest, wins in the end. In the end, I won.

And the most crucial piece was that lowly, underestimated autoresponder.

One of my favorite cult phrases is this one: **dark horse**. A little known, unexpectedly successful entrant.

Yeah… a "nobody" who surprises others by winning the race from behind. Don't you love it when you hear a would-be champion say, "Hey wait a minute, who was *THAT*???"

Better to be an underestimated nobody than an overestimated disappointment, in my humble opinion.

Use a dark horse strategy. Be the dark horse in the race.

Because it's not about how things begin, it's all about how they turn out in the end.

And you know what? It's not over. Because people who subscribed to that 5-day course years ago are still tuned in, still buying, still happily living on Planet Gary.

Most people want to build an online business by writing a Google ad, sending people to a product page, selling a product and pocketing the profit.

Nice work if you can get it. And seriously, that 3-step processes IS the core of many, many online businesses.

But it's pathetically easy to do and even easier to knock-off. People whose business is that simple are profoundly vulnerable to competition. Businesses that are no more sophisticated than that spring up in the morning and whither in the noon-day sun. If your business is this simple, *you'd better get your ass in gear and deepen your roots – and fast.*

For a business to survive a long time, it MUST have something that's hard to replicate. Now if your product requires a $200 million manufacturing process using plants that take 6 years to build, your product alone may be sufficiently unique.

But if your product is easy to knock off (and most are – somebody just sends it off to China and the rest is history) then something else needs to be hard to replicate.

So, let me tell you the easiest thing to do that SEEMS to "hard" to be replicated by most people.

Or more specifically it's NOT LIKELY to be replicated... by most people.

The secret is:

A lengthy and complex sales follow-up sequence.

That's it.
Let me use a simple example, for the sake of illustration:

Let's say you sell pet portraits and eBooks on pets with a focus on dog grooming.

You have dog grooming keywords, a dog grooming Google ad, a dog grooming sales letter and a dog grooming eBook.

Congratulations, you have the most basic kind of online business.

Problem is, the book sales will probably barely cover the cost of your clicks and there are 10 other people just like you. Not a stable or secure business.

So, let's add a dimension of* sophistication:

You offer a white paper or guide to up-and-coming dog groomers, instead of going for the 1-step sale.

People download the report and then over the next few weeks, they get autoresponder emails that help them digest the content of the report. These messages give people links to the page where they can buy your book.

After they buy the book they're put on another autoresponder sequence that introduces them to an advanced version of the book. It also introduces them to your pet portraits.

The autoresponders also describe the importance of organic dog grooming shampoos and why the ones you sell are head and shoulders above all the others. (Bad pun, I know.)

The messages tell dog grooming stories. Stories of dog grooming shop owners who have achieved remarkable success with their businesses by marketing and publicizing their businesses better.

They invite people to join a dog groomer's discussion board and membership site.

They invite people to a dog grooming conference where the latest techniques and technologies are discussed.

They get automated FAX broadcasts 4-5 times in the first 2 months.

There's an automated Teleseminar that is broadcast 1 week after they subscribe.

They get Voice Mail broadcasts to announce the special teleseminar.

They get links to special instructional videos and interviews.

They get postcards and letters in the mail. Maybe they receive a CD or a DVD.

Every time they buy a product or participate in a teleseminar, they get added to lists that further nurture their interest.

In all, the total sales sequence has 50 steps not 3.

THAT is a business that will survive while others come and go and come and go. This is the power of the silent underground.

It's like a tree whose roots are even bigger than the part that's above ground. So, a hurricane or wind storm can't take it out.

That, my friend, is the key to long term success.

Now, here's the KICKER that I alluded to in the title of this section:

Once at a seminar, an Internet marketing guru described what I'm describing to you – the immense power of complex, thorough customer follow-up systems. He described the 20, 30, 50 step sales funnel. With email, snail mail, FAX, teleseminar, video, whatever makes sense.

He said, "I could stand in front of a room full of people and describe every single step of one of these businesses – a business that makes the owner a million or two million dollars a year – and one by one everyone in the room will either fall asleep or leave. As simple as this is, almost NOBODY goes to the trouble of doing this. Even when you stand in front of a room and show people every single detail of the whole thing."

"The ones who do easily control entire markets, just for the trouble of creating the 30 steps."

That is what I call **The Autoresponder Irony.** That a thorough follow-up sequence is so deceptively simple yet powerfully effective that almost nobody bothers to do it.

Dude, I'm telling you, if you're looking for shortcuts in the world, this is one of the BIG ones. A monster opportunity that's disguised by its glamor-less-ness.

Dude, if you have an online dog grooming publishing company and you decide to have 50 steps instead of 3, honestly... *how hard is that?* A few weeks of focused effort... maybe? Sitting with your laptop at your favorite coffee hangout, sipping lattes? Watching people come and go, inserting people-watching stories in the middle of your sequence?

Yeah baby, drinking coffee and writing follow-up messages, that's h-a-a-a-a-r-d work!

Crap. Anybody who thinks that's too hard deserves the punishment of a *real* job.

Years of business longevity for a few pleasant weeks of effort? That's the power of the Silent Underground.

Harness it.

3 Keys to Building Your Art Brand Online

Have you ever wondered what is the basis of building a strong art brand online? Have you wanted to build an art brand online but was not sure how to do it?

There is a lot of talk these days about building brands. There's lots of books on the subject and lots of articles about it on the internet.

Building a brand takes time and effort. It is not something that is done quickly, or something that happens accidentally.

There are 3 main keys that you must have to build a strong art brand online.

If you work on building and maintaining these 3 essential elements, you will be way ahead of the pack in building your art brand online.

1) Content

In order to build a strong art brand online, you must deliver quality content. **You must create interesting content that your readers will be eager to read and share.**

The best method of delivering content on the internet is a WordPress blog.

There is no better way to build a strong art brand online than to create a quality blog.

The blog is the hub of your art brand online. Your blog establishes you as an expert in your field. **It is the platform from which all other brand building strategies grow and thrive**

2) Social Media

Social media plays a key role in establishing your art brand online. Social media is all about building relationships.

Relationships can be established and maintained by providing high quality content. Once again, it all comes back to content. High quality content is king.

When you produce content that your readers love to read, they will be eager to share it with their friends on their social media networks.

Only broadcasting news of your latest projects, sales, or promotions is a big turn off in social media. You will want to share your promotions and latest projects, of course, but in a balanced way. I found the 80/20 rule to work here. Share 80% high quality content with about 20% sales messages, promotions and personal projects. This gets your sales message through without turning off your followers or having them "unlike" you.

3) Email Newsletter

The last important key in building a strong art brand online is creating and maintaining an email newsletter. **Email newsletters help to solidify your art brand online.**

A **regularly timed email newsletter** showing up in your subscriber's inbox **helps to build trust in your brand and to keep up brand awareness.** When creating your email newsletter, be sure and put your brand name in the "From"

section of the email. In my emails, I use Gary Bolyer in the "From" section as this is the brand name that I am building now.

Once again, content is the key to a great email newsletter. When you give valuable content that your readers will look forward to receiving, your messages will be eagerly opened and read.

You will, of course, want to put sales messages and promotions in your email newsletter. Once again, as in Social media, the 80/20 rule works well here. Try 80% high quality content with about 20% sales messages and promotions. This will keep your readers engaged without losing too many to the "unsubscribe" button.

Which is Best? Facebook Likes, Twitter Followers, or Email Newsletter Subscribers?

Have you ever wondered which is better, which is worth more to your internet art business? 1,000 Facebook Likes, 1,000 Twitter Followers, or 1,000 Email Newsletter Subscribers?

These questions are at the heart of a successful internet art business. If you are like most other artists who are trying to get their internet art businesses up and going, **you have a limited amount of time and money to promote your new venture.**

So, you must focus your efforts on the most profitable platforms first, and then diversify from there.

But which platforms give you the most return most quickly? There are so many ways to promote yourself on the internet. Of course, you have the big social platforms like Facebook and Twitter. These powerhouses **can't** be overlooked.

You have blogs, static websites, and email newsletters to get the word out about your work. These few that I just mentioned above are only the tip of the iceberg in the internet arena. So, the choices are dizzying to say the least.

Which is Better?

The Direct Marketing Association (DMA) has quantified these platforms into a dollar amount comparison. It makes it easy to understand which platform gives you the most return for every dollar that you spend.

Do you know what they recommend?

They recommend **Email newsletters as the most profitable of all the platforms**. Their studies show $44 returned for every $1 invested in an email newsletter.

By comparison, social media such as Facebook and Twitter only returned $12 to $20 for every $1 invested.

So, email newsletters were by far the leader with more than twice as much returned per every $1 invested. Wow! Twice as much return. You can't argue with that.

So, using these statistics as a basis for a beginning strategy for your internet campaigns, it becomes crystal clear where you must focus your efforts first: an email newsletter.

I have seen this time and again in my internet business. The email newsletter is where the profits are to be made. If someone offered to give me 1,000 Facebook Likes, 1,000 Twitter

Followers, or 1,000 Email Newsletter subscribers, I would take the 1,000 Email Newsletter subscribers any day. I use Aweber as my email newsletter provider.

Why Residual Artist Profits Are Better Than Wages

Which do you think is more valuable, residual profits from an online art business or wages?

Which has more security over time?

This is a tough issue.

Our culture teaches us to expect wages for our time–the person who makes ten dollars an hour wants twelve, the attorney who makes a hundred dollars an hour wants to work his or her way up to two hundred, and so on.

Whatever the level, we're talking about wages, or linear income. **Is your income linear or residual?**

Here's how you can tell. Just ask yourself this question: How many times do I get paid for every hour I work? If you answered, "Only once," then your income is linear–you are making wages. Salaries offer linear income. Doctors and dentists earn linear income. Linear income is very time dependent–typically, when you don't show up for work, or you take a day off, your paycheck stops.

Why Artist Residual Profits Are Better

With residual income (profits), you work hard once and it unleashes a steady flow of income for months or even years. You get paid repeatedly for the same effort. For instance, if you wrote an eBook about how to paint in oils and started selling it on your artist blog, then you would create residual income or profits.

You can sell the eBook tens of thousands of times, repeatedly, without any more effort on your part.

I get emails from people almost every week who have been let go by major companies. They write that they are angry because, after twenty or twenty-five years of working for security, they are now left out in the cold.

No matter how wonderful your company is, if you're making a linear income, you are not secure; you only have the illusion of security.

Working as an employee, with no connection to the profits you help bring in, is not security. It's just the illusion of security.

You can work for linear income and still create residual income in other ways. Internet marketing, visual arts, and blogging are just a few of the ways that offer artists potential residual income.

Something changes when you start working for profits rather than wages. I've seen the guy who'd always been too tired to go to work become motivated to stay up all night writing his first art blog posts. Or the woman who'd felt depressed and exhausted all week spend forty energetic hours on the weekend writing her first eBook.

I've seen a person's attitude, voice, and face change when he or she starts to embrace this new way of working. The possibility of profits is empowering and releases the deepest reserves of creativity and energy.

Working for wages is limiting–the temptation is to do the very least to maintain the predictable and limited reward.

Social Media for Artists – How to Conquer It and Have a Life Too

Social media can be fun, a wonderful way to network and spread the word about your art to the world and enjoy new collaborations.

It can also be a terrifying time sink of gargantuan proportions of the kind where you wake up on Saturday morning and realize you have spent the entire week poking at Facebook and Twitter and achieved NOTHING else. Not good.

So, this little post deals with a few ideas to help you deal with social media in ways that are a bit more efficient and which can help you reclaim your life.

Scheduling – for fun and relaxation.

There is a big secret to reclaiming your life from the tentacles of social media... and that secret is SCHEDULING... If you can limit the time you spend on social media to, say one or two 15-minute session it stops you from getting embroiled in addictive checking. You can set up a bunch of links first thing in a morning to post later. **Then you can close Twitter & Facebook and get on with the good stuff, like painting and creating.**

Will scheduling make me an evil robot?

Looking on Twitter it's easy to spot the absolute abuse of scheduling software. Streams of random links and spam, offering ways to make $3000 dollars at home, posted by bots with no human interaction. This is clearly not where you want to be, but it doesn't have to be like this.

You can use scheduling to post your links but take time in your 15 minutes update time to check on what's happening, thank people for retweets, chat and interact with people. You can still be human. Scheduling just means you get all the grunt work done, leaving more time for the lovely enjoyable human stuff.

Which software to use?

There are some great pieces of free software online which will help you automate many aspects of your social media presence. These are my favorites...

Hootsuite

I use Hootsuite as my main weapon of choice when dealing with Twitter. You can set up tweets and schedule them for any time. You can also see your streams of followers, mentions and direct messages extremely easily making it a snap to keep on top of what is happening. I spend 15 minutes or so first thing scheduling my posts for the day and replying to messages. I will then check back towards the end of the day to chat. It also allows you to add other social services including Facebook.

Networked Blogs

Networked Blogs is extremely handy for taking your blog and feeding it into Facebook. This is my main use for this application but you can also feed your blog straight to Twitter too.

Divr.It

I have recently discovered and found it useful for sending an RSS feed from a blog into individual Twitter posts.

The wonderful thing about dlvr.it is that you can schedule the posts for the best time for you and specify how many are posted at any one time, preventing flooding. You also get stats on how your posts performed. Extremely informative.

Reclaim your life...

Automating some parts your social media presence will really help you to free up your life from some of the more time stealing elements of this area of the web.

But most Importantly it will allow you to focus on the important part of social media. **Communicating with people.**

Chapter 6. E-Commerce Flowchart and Business Plan

In this chapter of the eBook I am going to provide you with an easy-to-use flowchart and business plan. I suggest that you begin to act as soon as possible on the steps outlined here. It's best to put a date of completion on each step. This will keep you motivated and help you to hold yourself accountable for getting things done.

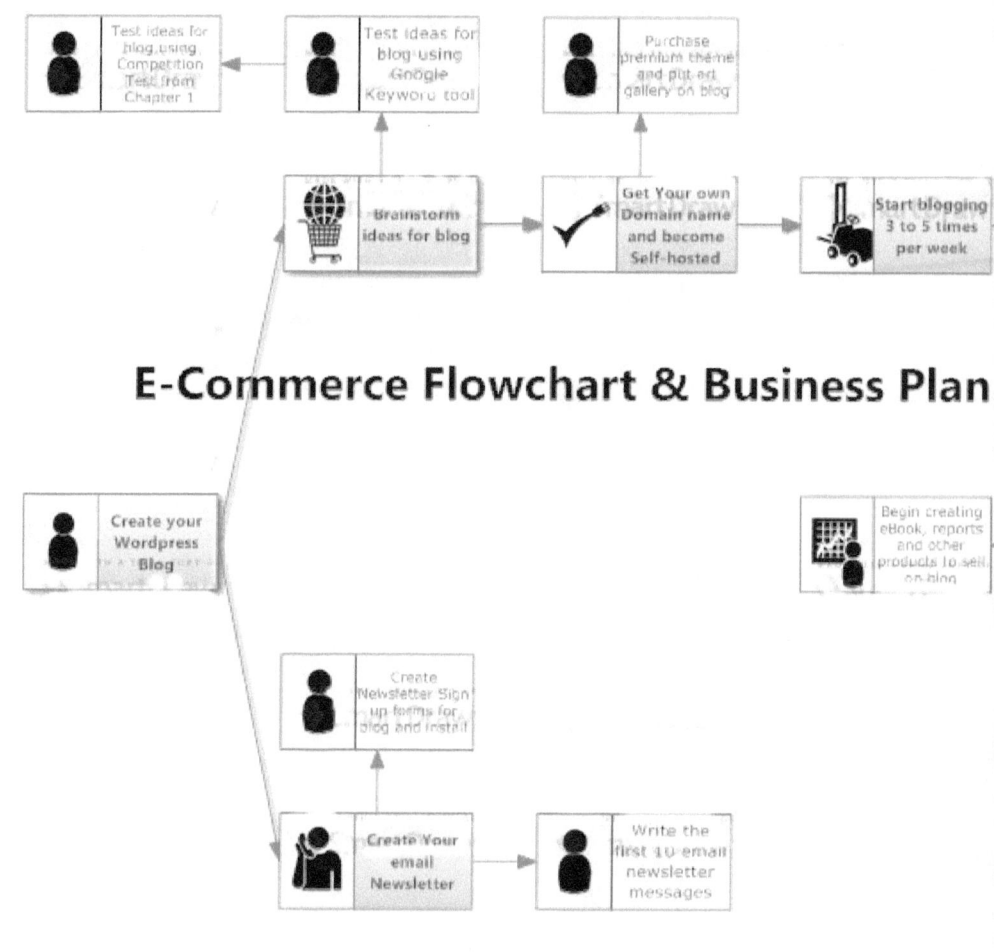

E-Commerce Flowchart & Business Plan

Step 1. Create your Foundation Platform or WordPress blog.
This is the easiest and most fun of the steps. Simply go to Wordpress.com and sign up for your free blog. I go more in detail for this step in Chapter 1.

Step 2. Brainstorm ideas for your blog and email newsletter.

Begin putting the ideas from Exercise 1 in the Course Overview from page 7 on paper. Write down as many ideas as you can that you feel you might enjoy blogging about.

Step 3. Test blog ideas with Google Keywords Tool.
Perform Exercise 2 from page 26. Follow the instructions on page 25 in Chapter 1 with the section heading "Two Tests to Predict Art Niche Success." Narrow down your list of ideas for your art blog topic to the top one or two.

Step 4. Test blog ideas with Competition Test
Continuing performing Exercise 2 from page 26. Follow the instructions on page 25 in Chapter 1 with the section heading "Two Tests to Predict Art Niche Success." Narrow down your list of ideas for your art blog to the top one or two.

Step 5. Create your Email newsletter.
Follow the steps in Chapter 4 to create your email newsletter. Pick your email newsletter provider and sign up.

Step 6. Create Email Newsletter Signup Forms and install on blog
Once you have set up your blog and signed up with an email provider, then you will need to put signup forms on your blog. Follow the instructions given by your email provider to do this. There are also instructions about this in Chapter 4.

Step 7. Write your first 5 or 10 email newsletter messages.
Now is the time to go ahead and write the first few sequences of your email newsletter messages. At this point you should have tested your blog ideas and have settled on the focus for your art blog.

Step 8. Get your own domain name and become self-hosted.
This step is not critical now. But I suggest that you go ahead and do this as soon as you feel comfortable doing it. I blogged for about a year before I took this step.

Step 9. Get your Premium Theme and install it.
You will not do this step until you have completed Step 8. Once you have completed Step 8, I recommend you get a Premium Theme as soon as possible.

Step 10. Start blogging 3 to 5 times per week.
Now that you have zeroed in on the main idea for your art blog, begin blogging as much as possible. Five times per week is best. Your goal is to reach one hundred blog posts as soon as possible. See Chapter 3.

Step 11. Create your social media pages on Twitter, Facebook, Youtube, etc.
Go ahead and create all your social media pages. Link your blog to them and link them back to your blog.

Step 12. Focus on one social media site and become an expert.
Focus on your favorite social media site and become an expert on that site. Read every book you can on that site. Learn how to post, when to post, what to post. Be an expert in every way on that one site within a year. Then pick the next site and do the same thing.

Step 13. Announce each recent blog post on every social site.
Each time you write a new post announce it on every social site. Put links and a call to action so that readers will want to come read your blog.

Step 14. Continue to blog 3 to 5 times per week.
Continue to blog every week at least 3 times. Five times is best. Make a writing schedule and stick to it.

Step 15. Begin creating your eBooks, reports, art prints, originals to sell on your blog and newsletter.
Begin creating any information products or art products that you are going to feature in your blog and email newsletter. This can be reports or eBooks that fit with the theme of your blog. You will also need to begin testing art products on your blog such as prints and originals. Keep testing all products until you come up with the ones that work best. You can also begin testing and adding affiliate program products to your mix.

Smart Art Marketing FREE Video Training

If you'd like to find out more about how to nurture your audience, make more sales, and automate your marketing – go check out this FREE 3-part video series masterclass training at GaryBolyer.com.

I'll take you through everything in this book via video – and a ton more to boot.

This free video training series has helped over 10,000 artists and entrepreneurs grow their online art business. And for those of you ready to take it to the next level, there's a premium option too – and enrollment is officially open.

Free Marketing Training for Artists

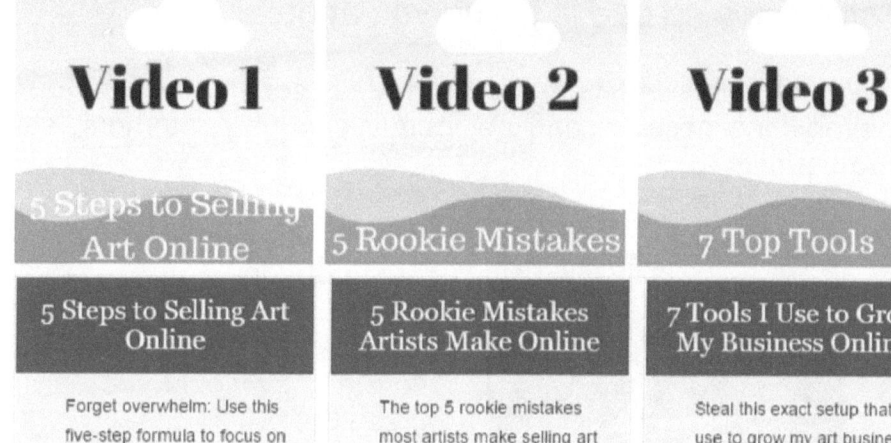

Go check it out here (it's free): GaryBolyer.com

I'll see you on the inside!

Gary Bolyer

Free eBook Reveals Secrets to Selling Art

So, you want to sell your art? Here are surefire strategies no one is telling you about.

Why do some artists **make money so easily** — while you try everything possible and get barely enough customers, sales and profits?

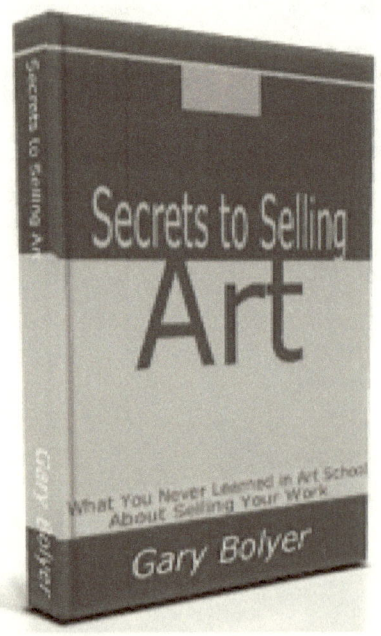

What if there was a way you could **convert 15%, 25%— even 50%** or more of your customers, galleries, how much more money would you earn as a result?

If you could read just **one** eBook about how to turn your efforts into an unstoppable selling machine, *Secrets to Selling Art* is it. I dare you to read this entire publication and not change the way you sell to art galleries.

Grab my bestselling eBook *Secrets to Selling Art* (it's free): GaryBolyer.com/Free-eBook

www.ingramcontent.com/pod-product-compliance
Lightning Source LLC
Chambersburg PA
CBHW021815170526
45157CB00007B/2594